Merry Christmas Pammy
with love,
Becky

December, 2008

# HOUSE OF WORSHIP
## SACRED SPACES IN AMERICA

© 2006 Assouline Publishing, Inc.

Assouline Publishing, Inc.
601 West 26th Street
18th floor
New York, NY 10001
USA
Tel: 212-989-6810   Fax: 212-647-0005

www.assouline.com

ISBN: 2 84323 880 3

Color separation: Gravor (Switzerland)
Printing:  SNP Leefung

DOMINIQUE BROWNING
AND THE EDITORS OF
HOUSE & GARDEN

INTRODUCTION BY
THE REVEREND PETER J. GOMES
HARVARD UNIVERSITY

# HOUSE OF WORSHIP
## SACRED SPACES IN AMERICA

ASSOULINE

Several writers contributed chapters to this book:
Carol Flake Chapman,  Earl Shorris, Lawrence Klepp, Georgia Dzurica,
Judith Nasatir, Mayer Rus, and Katrine Ames.

The remarkable, resourceful, and passionate Beth Dunlop, however, not only
wrote the lion's share, but is responsible for having found many of the
fascinating houses of worship that are included here.

# CONTENTS

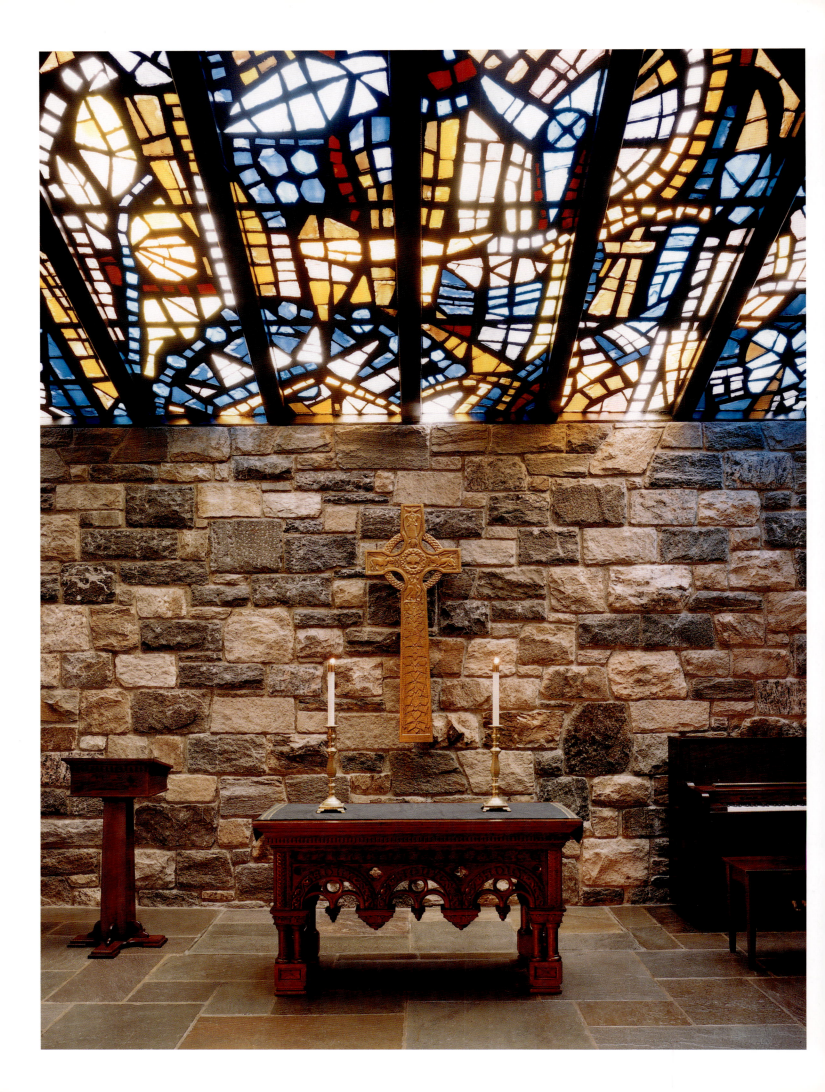

# FOREWORD

## by Dominique Browning

I became aware of the power of architecture as a child sitting in church. This was in suburban Connecticut, in what was then the small town of Stamford. We were members of the First Presbyterian Church, an institution my father picked simply because he liked the Sunday school; I'm sure the warm, friendly, accepting atmosphere of the congregation was appealing to a newcomer from Kentucky with a wife from Casablanca. My father was in charge of our religious education; my mother stayed home with the babies. My sister and I would be dropped off at Sunday school while my father did his rounds at one hospital; then he would pick us up and take us to lunch at the cafeteria of another. So, right off the bat, going to church meant a special outing.

The classroom part of Sunday school left no impression on my memory. Chapel was another thing. Grade-school children were herded into an intimate space—away from the main church, in which the grown-ups prayed—for 15 or 20 minutes of "beginner" worship. The chapel was a dimly lit, cool space; the floors, as I recall, were stone, and the ample, clean-lined wooden benches had a solid feel. There was a wooden cross, also unadorned, as well as a pulpit and an altar. I didn't know a thing about modern design versus traditional design, and I certainly wouldn't have had the critical capacity with which to judge the place in which we sat. I just knew that I loved going there.

It was quiet, and that was a welcome respite from the noise of school and a house full of babies and piano practice and battles. The quiet in the chapel had a special force; it wasn't like the anxious, droning quiet enforced by a teacher during a test, nor was it the humming quiet of the house when I was lying in bed late at night. It was more like the quiet of the thick woods behind our house, a quiet that settled over my shoulders as soon as I climbed down the shaded hill and reached the sparkling sunlight of the river, a quiet full of significance, out of which anything might spring. A quiet of anticipation and discovery—that's what the chapel, which came to mean prayer, felt like to me.

The chapel was also beautiful. Its quiet nature was expressed in the handsome, strong, simple lines of everything in it; that somehow had the effect of quieting the mind. The plaster was smooth and looked burnished. The stones set into the walls were old and worn and interesting; they had been sent from other sacred places around the world. Their inscriptions referred to mysterious, faraway, and exotic lands. Later in life, when I learned about modernism, I could not understand how it came to look so "cold." My first experience of modern architecture was one of a place of simple, warm, glowing grace, and it is included in this book.

OPPOSITE PAGE: The intimate stone-walled chapel at First Presbyterian Church in Stamford, Connecticut, is used for Children's Worship as well as for small weddings and funerals.

I went away to school, and then moved to Texas. I forgot all about church—and didn't return to it for many years. When I did, I was divorced, the mother of two children, and looking for solace. The moment I walked into the chapel again, peace settled over my shoulders, as it had always done, and I felt soothed by that familiar, embracing quiet. By then, too, I could appreciate the craft of the design around me, as well as the value and refinement of the materials.

I didn't consider the impact of that space on my aesthetic sense, though, until about ten years ago, when I began to think about the pages of *House & Garden*. When I was asked to become the editor of the magazine, I decided to include in its coverage a column called House of Worship. I wanted the magazine to reflect a recognition that houses and gardens encompass much more than the private places in which we live and play. There are houses and gardens that belong to a community as well, and they can become the most significant factors in our experience of home.

I wanted to explore the connection between spirituality and design. How do architects create space for prayer? How do they create places that allow people to open their hearts and minds to some sense of a greater being or a higher purpose? I believe that anyone can worship anywhere, and that a prayer whispered under a canopy of redwoods is as powerful as one that rings out in a cathedral. But churches, and synagogues, and mosques, and temples, and meetinghouses have to do with building a community of worship or study; once the decision is made to fix a place, everything is called into question. What will it look like? What values will it express? What will its relationship be to light, and to darkness? What kinds of materials are appropriate? What is the connection between scripture and architecture? And above all, what is the nature of a spiritual quest; what quality of space best serves it? These are only some of the questions our writers have tried to address in conversations with architects as we explore America's sacred spaces.

You will meet talented and dedicated designers and parishioners in these pages. You may find your own place of worship represented here; you may find inspiration, wisdom, and guidance for creating new places of worship. While we may not have the abundance of the ancient stone cathedrals of Europe, we are blessed, in the United States, with an abundance of variety and imagination in our sacred buildings. It is perhaps not too much to hope that we can gain, from our visits to houses of worship, some appreciation for the infinitude of angles that grace any spiritual path.

OPPOSITE PAGE: First Presbyterian's dramatic carillon, which was designed by Wallace K. Harrison, was added in 1968. Made of reinforced concrete, it has 99 steps leading to a full complement of bells.

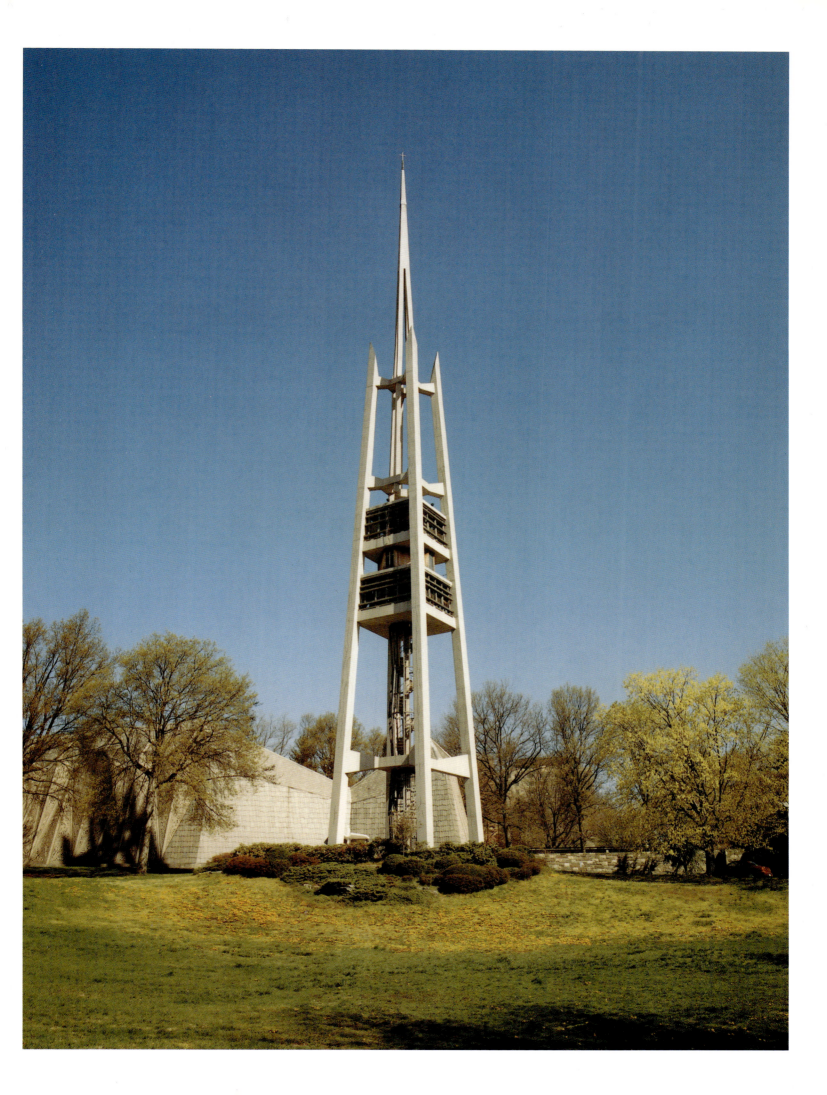

# INTRODUCTION

## by The Reverend Peter J. Gomes

When the president of Harvard University confers degrees in architecture and design at commencement, he proclaims that the architects and designers are competent "effectively to shape the space in which we live." Among the spaces in which we live are those that are shaped to accommodate our worship—spaces as varied as the communities they are designed to serve. The relationship between space and function is commonplace among those who know even a little about architecture, and the most casual observer of a European Gothic cathedral, for example, will begin to imagine the relationship between soaring stone and glorious glass, and what is meant to take place within.

Fortunate are those who stumble upon such places at a time when an act of worship is taking place. To stand in the back of a French cathedral and see priests ministering far away at the high altar at the east end, or old women saying their beads in front of a side chapel altar aglow with vigil lights, is to see something of the building at work. In England, it is usually the sound of a choir or organ or the sight of a modest procession of clergy that suggests the ancient sustainability of the space, and the ubiquitous exterior scaffolding moving around the building like stars in their courses suggests that the building itself is never finished, but always a work in progress.

America has no Gothic past, and our vernacular ecclesiastical style represents a stirring mix of our preferences and traditions. In New England, the white-paneled wooden meetinghouse on the green, a staple scene of Christmas cards and calendar art, speaks of the plain style of Puritanism, refined and enhanced as the distance increased from the mother country and the first generation's rigorous austerity. By the eighteenth century, New Englanders of means were attempting to build urban churches after the style of London's Sir Christopher Wren, when elegance was no longer sublimated to efficiency, with one result the ambitious space of Boston's Christ Church on Salem Street, better known as the Old North Church, immortalized by Henry Wadsworth Longfellow's account of Paul Revere's ride. Perhaps the most beautiful wooden church in the country, the First Baptist Church in America, on College Hill in Providence, Rhode Island, was built, as its plaque says, "For the public worship of Almighty God and also for holding Commencement in," making clear its connection to nearby Brown University.

In the eighteenth century, urban Roman Catholic immigrants constructed churches that reminded them of the glory of faith in their native lands.

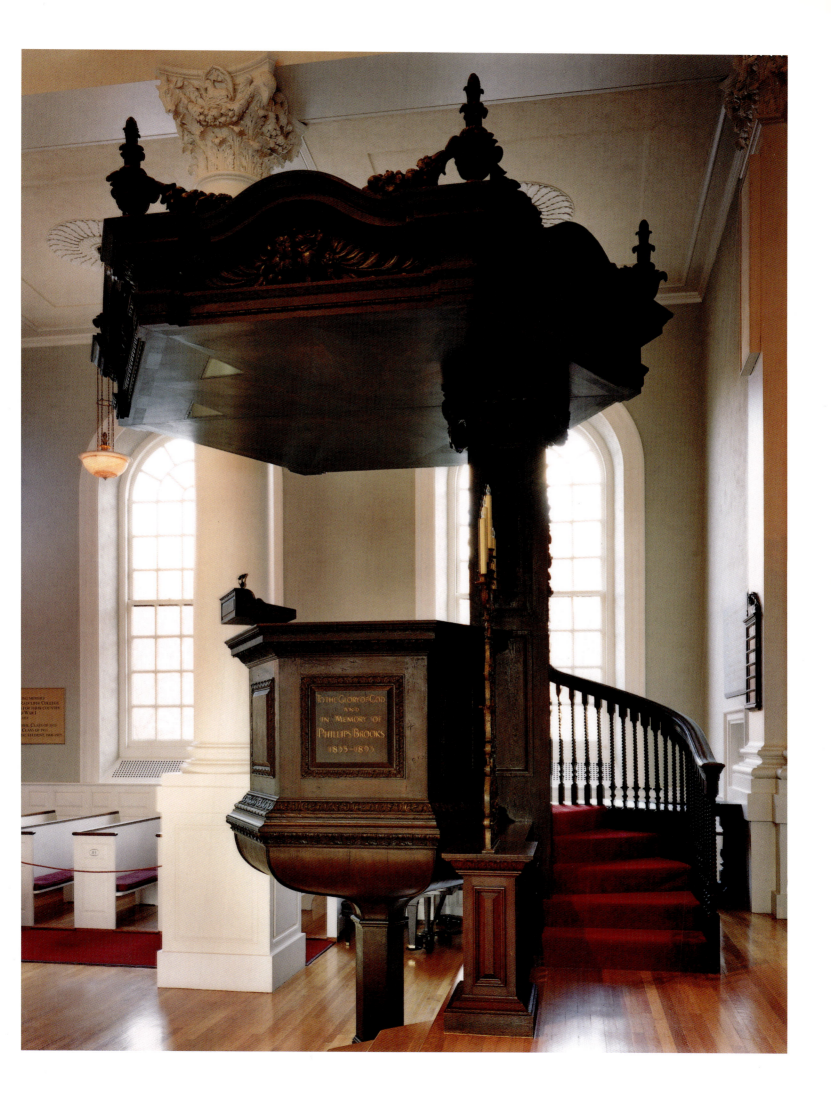

TO THE GLORY OF GOD
AND
IN MEMORY OF
PHILLIPS BROOKS
1835–1893

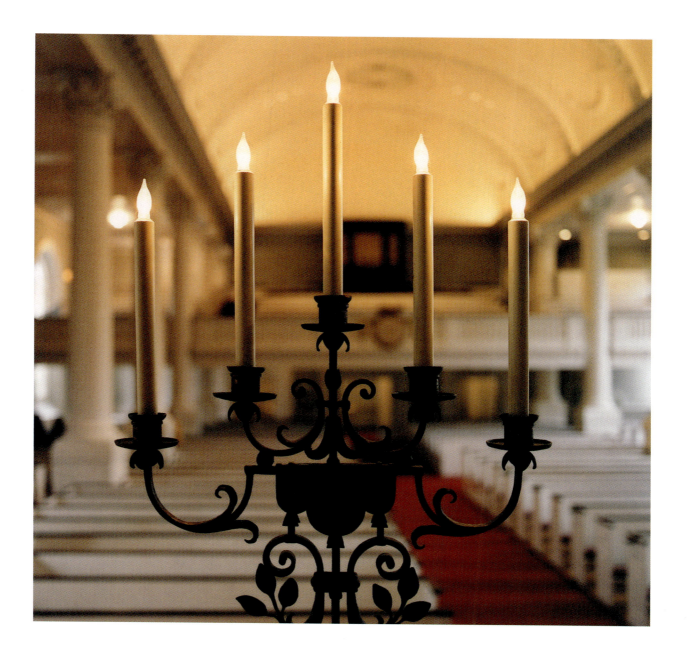

Usually they built in brick or stone, as soon as they could afford to, and placed great emphasis on Gothic shapes and high towers. Three doors on the side street, with lots of statuary and stained glass, announced to all and sundry that the Catholics had arrived and were here to stay. One of Boston's colorful Irish Catholic politicians delighted in deriding the ebbing Protestant establishment with the comment, "You people go to wooden churches."

European Gothic architecture twice became American architecture of choice: first, at the time of the Gothic revival in the first half of the nineteenth century, when the growing Episcopalian population built its churches in homage to the parish churches of England, an Episcopal church being designed to evoke the continuities of Anglicanism and to stand in marked contrast to the inheritance of the meetinghouses and the ambitions of the Roman Catholic churches. The second revival, stimulated by such giant architects in the field as Ralph Adams Cram and Bertram Grosvenor Goodhue, occurred in the first quarter of the twentieth century, when any institution with an eye toward its reputation built a church or chapel in the Gothic style. The National Cathedral in Washington, D.C., the Riverside Church in New York, and the chapels

at West Point, Duke University, Princeton University, and the University of Chicago all clad themselves in Gothic array, as did so many liberal arts colleges that the term "Collegiate Gothic" entered the lexicon of design. Everyone knew what it looked like, if not what it meant.

The church I have served for the past 30 years, the Memorial Church of Harvard University, is an intentional exception to the Gothic trend. The Memorial Church was built in 1932 after the design of Charles Allerton Coolidge, of the venerable Boston firm of Coolidge, Shepley, Bulfinch, and Abbott, and the president of Harvard, Abbott Lawrence Lowell, who commissioned it and had strong views about everything to do with it. Lowell inherited a point of view, shared by his predecessor, the patrician Charles William Eliot, that Gothic was somehow un-American, antidemocratic, foreign, and even Catholic, and that it suggested a romanticized view of what most people would consider the Dark Ages.

The Harvard chapel, he decided, would draw upon Harvard's own eighteenth-century brick vernacular, with significant homage to the London churches of Sir Christopher Wren. High vaulted ceilings, large windows of clear glass, and an obvious absence of iconography would characterize the space designed for listening, and the largest piece of furniture would be the pulpit, with its enormous sounding board. The most conspicuous feature was to be a screen of oak and gilded metal that would provide a permanent separation between the chancel and the choir. At the east end, where in any other building of the sort an altar would stand, there would be a secondary central pulpit beneath a Palladian window of clear glass. Through this window could be seen the singularly New England form of a wineglass elm tree.

All worship spaces, from the great cathedrals to the smallest storefront Pentecostal temples, suggest something more than the private agenda of those who visit them, which may be what the Bible has called "the beauty of holiness," or perhaps, as the architectural aesthetes might have it, "the holiness of beauty." Whatever it is that is evoked by these buildings in their bewildering variety, we who have the privilege of seeing them are the better for it. The skylines of our cities and towns now dominated by the glass and concrete towers of commerce were once punctuated by the towers, steeples, and domes of our houses of worship, and nowadays, when something of the old skyline manages to rise up through the new commercial towers, we are perhaps persuaded, at least in part, that we have not yet thoroughly lost our way. It is worth noting that while the Twin Towers of New York City are, alas, gone, the little eighteenth-century Episcopal church near Ground Zero that played such a vital role in the rescue work still stands, a house of God and of prayer. Surely there is something powerfully hopeful in that.

OPPOSITE PAGE:
Rev. Peter J. Gomes, who has been at Memorial Church since the 1970s, stands in front of the pews in the extraordinary interior, which is filled with natural light.

Peter J. Gomes
Plummer Professor of Christian Morals and
Pusey Minister in the Memorial Church
Harvard University

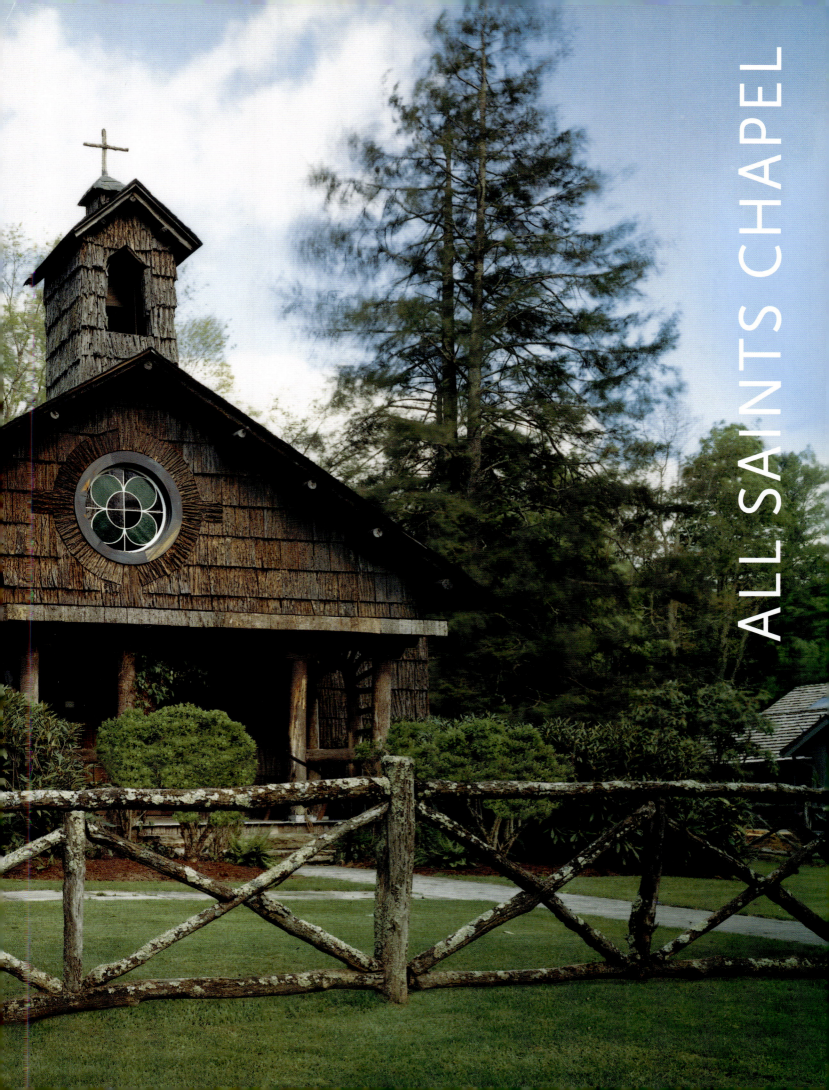

ALL SAINTS CHAPEL

Up in the Blue Ridge Mountains of North Carolina, a chapel completed in 1913 is a remarkable testament to the glory of nature.

High up in North Carolina's Blue Ridge Mountains is a historic chapel that is not just an ode to an era but an eloquent reminder of the fragility of the world around us. Inside and out, this exquisite little chapel is clad in bark shingles of American chestnut, a tree that in the course of 50 years became virtually extinct. All Saints Chapel sits without much fanfare in the heart of Linville, a mountain resort community that has been luring summer residents for more than a century.

On summer and autumn Sundays, the bells call worshippers to sing, pray, and remember that, as Rev. Brian Sutkin said one chilly morning, "the ordinary can be extraordinary."

No words are more apt for this Episcopal chapel. It is perfectly proportioned, with chestnut boughs bent to form arches and shaped into crosses, and exposed log timber beams laced across the ceiling. Light and sound bounce off the ridges of the chestnut shingles, embracing the congregation. The lessons of the day are about humility and modesty. The Bible reading is from Psalm 31: "Be my strong rock / A castle to keep me safe / For you are my crag and my stronghold."

The architect of this rustic chapel was Henry Bacon, whose best-known work is the sober and searing Lincoln Memorial in Washington, D.C. The two buildings were designed almost simultaneously, shortly before World War I. In many ways they are opposites—one is remote and modest, the other prominent and momentous—and yet each shows off Bacon's masterful hand.

An avid classicist, Bacon was also an extremely modest man. Christopher Thomas, an architectural historian who studied Bacon for the book *The Lincoln Memorial and American Life,* says that "few architects are so identified with a single work," noting that though Bacon's practice ranged to include libraries, banks, academic buildings, houses, and more, his lifelong focus was on the design of memorials and monuments, a rare specialty even in a period much more given to commemorations. "He was a very underrated architect of his era," architectural historian Tony P. Wrenn says.

To get to All Saints, you must travel twisting mountain roads with astonishing vistas. Few landscapes are more compelling than that of the Blue Ridge Mountains, with their discrete layers of green and blue-green, blue and blue-gray etched against an often misty sky—"thin-gray thin-dusk lovely," Carl Sandburg called them. The forests are interspersed with rivers, valleys, chasms, and waterfalls ("arranged with an order and a symmetry as rare as it is beautiful," as an 1896 publication by North Carolina's Board of Agriculture put it). Many geologists regard the Blue Ridge, formed some 650 million years ago, as the world's oldest mountain range, with granite outcroppings more than a billion

PREVIOUS PAGES: The tiny church was designed by Henry Bacon. It remains unchanged, a memorable spot for worship, and shares an architecture with the area's lodges.
OPPOSITE PAGE: Inside the intimate church, exposed log beams give the sense of a forest canopy.

years old. Yet it is in many ways unheralded, largely undocumented by the country's great nineteenth-century landscape painters.

By the time Linville was founded, Asheville was long settled and home to the remarkable Biltmore Estate, but the higher mountains remained the discoveries of an intrepid few. Though accounts of Linville's origins vary, it was in the 1880s that Hugh MacRae, a young MIT engineering graduate from Wilmington, North Carolina, who was running his family's mica works, oversaw the purchase of 16,000 acres. Part of it was set aside as a resort for "cottagers" from Wilmington and other southern towns.

We can only imagine the awe of early visitors; a Harvard professor seeing Linville in 1891 wrote that he had found "the most peculiar and one of the most poetic places I have ever been in." Bacon, too, had grown up in Wilmington, where he established lifelong friendships, significantly with the MacRae family. When Bacon was hired to design houses for the MacRae resort, he used the chestnut shingles that eventually set Linville apart and gained it a spot on the National Register of Historic Places. "The church is the epitome, however," says Michael T. Southern, research historian in North Carolina's State Preservation Office, "and it is stunningly beautiful."

In many ways, All Saints recalls other hand-hewn buildings. Yet it is set apart, to a certain measure, by what Thomas called "the exquisite refinement" of the architecture, in which Bacon stripped a classic church form to its purest state, and likewise by the rich, tactile striations of the chestnut bark. The wood is everywhere, and its presence is compelling. The American chestnut tree flourished into the early twentieth century, when a rapid-spreading fungus blight from Asia infected it. By 1950, the beloved tree was all but wiped out.

This aspect makes those who know All Saints treasure it even more. "It's magical, precious," parishioner Mary Rinehart says. At the chancel, the fittings still reflect the designer's eye for an understated architecture that speaks volumes about time and place, God and nature, permanence and transience.

CENTRAL SYNAGOGUE

Gutted by fire, a nineteenth-century midtown Manhattan landmark is reborn in all its rich exuberance.

PREVIOUS PAGES: The synagogue has a basilica plan—a central nave and side aisles. The architectural lighting firm Fisher Marantz Stone worked with architects to create new lighting systems and chandeliers that interpret the spirit of the original fixtures.
OPPOSITE PAGE: The ceiling bears an eight-pointed star in a field of deep blue.

Extraordinary events have the ability to reinvest even the most shopworn clichés with fresh relevance and meaning. In the wake of the World Trade Center attack, New Yorkers searched desperately for any assurance that cruel destruction might ultimately yield to the forces of renewal and rebirth—that phoenixes really can rise from the ashes. One bit of eloquent testimony to the power of faith and determination could be found at Lexington Avenue and Fifty-fifth Street, where Central Synagogue was joyously rededicated only two days before the cataclysm downtown.

An eccentric architectural gem, Central Synagogue was finished in 1872 by the Prussian-born Jewish architect Henry Fernbach. The Moorish-style structure was distinguished by two minarets crowned with gilded onion domes, elaborate wall stenciling in a fantasia of nearly seventy colors, ornate stained-glass windows, and intricately detailed mosaic floors.

In 1998, disaster struck. Central Synagogue, a vibrant bastion of Reform Judaism for 126 years, was ravaged by a fire ignited by a contractor's blowtorch. The building was almost completely destroyed. Its exterior walls and cast-iron columns remained standing, but the roof collapsed in the center, and the extravagant interior fell victim to the twin scourges of fire and water. Some of the encaustic tile floors, decorative millwork, and stained-glass windows survived. Mercifully, no one was killed in the blaze.

The monumental effort to rebuild the synagogue began almost immediately, propelled by the passionate collective will of the 4,000-member congregation. Architect Hugh Hardy, of Hardy Holzman Pfeiffer, the firm responsible for the renovation and restoration of such New York landmarks as Radio City Music Hall, was called in to orchestrate the daunting restoration process.

"Our biggest challenge was to create a seamless integration of the new and the old, a place that appears to be a unified whole despite the combination of existing architecture, modern construction, and the elements of the interior that we were able to salvage," Hardy says. "There was a built-in assumption that we would re-create the building as the congregants remembered it, but we also needed to examine the ways in which the nature of worship has changed since the nineteenth century, particularly in the relationship between the clergy and the congregation."

Hardy's team, under the direction of Jonathan Schloss, Nina Freedman, and Caroline Bertrand, along with restoration architects DPK&A of Philadelphia, immersed itself in historic research. Central Synagogue's archives included Fernbach's original drawings and specifications, vintage photographs, and internal committee minutes (some of which had to be translated from German)

ABOVE LEFT: Creative Finishes, NYC, used more than 2,000 stencils and 70 colors to conjure the floral, star, and latticework patterns on the walls and ceiling.

ABOVE RIGHT: Rambusch Decorating re-created the stained-glass rose window on the building's east facade.

OPPOSITE PAGE: The basilica culminates at the magnificent domed ark containing the Torah scrolls.

that described repairs and architectural amendments undertaken over the years. This material was supplemented by research at the Museum of the City of New York and the New-York Historical Society. One of the more curious sources involved military surveillance photographs of Manhattan taken during World War II, which provided details of the striped roof pattern that had vanished decades before the fire.

After three years of labor by more than 700 dedicated tradespeople, Central Synagogue reemerged on September 9, completely new yet utterly familiar. "It was extremely important that the congregation would think of it as home when they returned—that the space would have the same feeling as before," says Central's rabbi, Peter Rubinstein. "This restoration honors the past, yet it is imaginative about the future."

CHAPEL OF SAINT IGNATIUS

Steven Holl's spare chapel at a Roman Catholic university in Seattle speaks to many faiths and is, in every sense, illuminating.

The gloriously unexpected Seattle sunshine streams into the Chapel of Saint Ignatius, casting patterns of color and light on the sanctuary walls. On this particular day, noontime Mass begins, appropriately, with a reading that paraphrases a psalm: "Let us go rejoicing to the house of the Lord. I was glad when they said to me, let us go to the house of the Lord."

This striking chapel, the cornerstone of Seattle University, offers testimony to the power of architecture to awe and amaze. It was designed by Washington-born New Yorker Steven Holl, who believes that architecture need not be tied to singular meanings, one-dimensional explanations, or unilateral ideas. His is an architecture of accident, intricacy, complexity. Holl designs buildings to be read much like poetry, on many levels—form, metaphor, symbol, structure.

Though the chapel's architecture is abstract and contemporary, it has its roots in far older traditions. Built in 1997, Saint Ignatius chapel was intended to be the spiritual anchor of a Jesuit university, but also to speak to worshippers of many faiths and origins, so the architecture had to transcend the expected. There is a deliberate plainness that evokes the monastic life, making the chapel somehow ancient, harking back to the earliest days of Christianity. The focus is spirituality devoid of the trappings of centuries. "The building already has the ageless quality that makes it seem to be part of the place and part of history," says Andrew Schulz, who was an associate professor of art history at the university at the time and closely observed the design and construction of the chapel.

It is cast concrete, with textured walls stained to impart an instant timeless patina. "The color is called Roman ocher, situating the church not only in this place but in that place—meant to resonate in that larger history," Schulz says. The concrete already has settlement cracks, giving the chapel a rough-hewn, handmade feeling. It is all tactile, down to the hand-combed plaster walls inside. "The patterns in the walls recede into flatness at some moments and leap to life and high contrast at moments of brighter light," says Father Gerald T. Cobb, a professor in Seattle University's English department and a Jesuit priest. "As clouds move overhead, the chapel really pulses, sometimes subtly and sometimes quite dramatically."

The university, founded in 1891 and very much a part of the city's urban fabric, is up a steep hill from the commercial and cultural nexus of downtown. The chapel sits at one end of the campus, which has a certain unobtrusive simplicity, with brick buildings connected by paths and open lawns. A reflecting pool lies in front of the chapel, and from certain angles the building seems to float in the water. A single rock—palisades basalt from Mount Rainier—and a box of coppery-toned wild grasses are set into the pool.

PREVIOUS PAGES: The building seems to float in the reflecting pool, which holds a rock of palisades basalt from nearby Mount Rainier. OPPOSITE PAGE: Local materials fill and define the chapel, which is full of small but powerful surprises, such as this madrone tree with a lantern hanging from one branch. The tree, the victim of a storm, stands in a corner of the sanctuary.

Though the chapel's architecture is connected to the age-old traditions of the Catholic Church, the materials root it locally. The benches alongside the pool are of Kasota stone; the chapel's imposing asymmetrical doors are Alaskan cedar. Holl designed the bronze door pulls to evoke the cowl of a priest's robe, a subtle gesture. The altar sits on legs that are the Greek letters alpha and omega. The artistry here is deliberate, the result of ten months of intensive study. After he won the commission for the chapel, Holl began a learning process that led him to the Black Madonna of the Abbey at Montserrat. It was there in 1522 that Ignatius of Loyola, in the process of transforming himself from soldier to saint, embarked on his lifelong journey of writing, preaching, and teaching. Holl found Ignatius "a very charismatic personality who wrote with poetic intensity and a deep philosophy."

A concept evolved from Holl's studies: the building would be "a gathering of different lights," taking symbolic form from the idea of seven bottles of light in a stone box, the central metaphor for the design. "It's really more poetic than architectural," Schulz says, "and then it became a matter of transforming that dream into something that withstands the laws of physics." The structure consists of 21 poured concrete panels that were lifted into place to give the church its powerful geometric profile.

Father Cobb points out that the bottles-of-light metaphor assumes concrete reality in six different rooftop "light scoops" that bring light into the chapel in unusual ways. Each illuminates a part of the chapel that corresponds to a moment in the worshipper's experience—the processional corridor, the choir area, the main altar area. "Holl considered the seventh bottle of light to be the external bell tower and pool area," Cobb says.

The interior is simultaneously simple and complex. The space soars, but it is not precisely vaulted. There is no stained glass; rather, a system of colored glass and painted baffles creates patterns on the otherwise unadorned walls— green, orange, yellow, red, and blue flashes of light play off the solid surfaces of the plaster.

Holl also designed the church's furnishings, including a rug that shows the significant landmarks in the life of Saint Ignatius. Artists, most of them local, created blown-glass light fixtures, icons, and sculptures. Artist Linda Beaumont covered the walls of the little Blessed Sacrament Chapel, which sits in a corner of the sanctuary, in beeswax and inscribed a Celtic prayer in the floor. At the center of this chapel is a local madrone tree that fell in a storm. To one side of the altar is the "reconciliation room," or confessional, a tiny space infused with brilliant light.

Holl grew up in the Seattle suburb of Manchester and returns often. On one recent visit he stopped at a grocery store and decided to charge his order. The clerk noticed that his credit card read "Steven Holl Architects," and said to him: "You should go see the new chapel. It's stunning." It was an unforgettable moment, Holl says. "To me, that was worth more than anything."

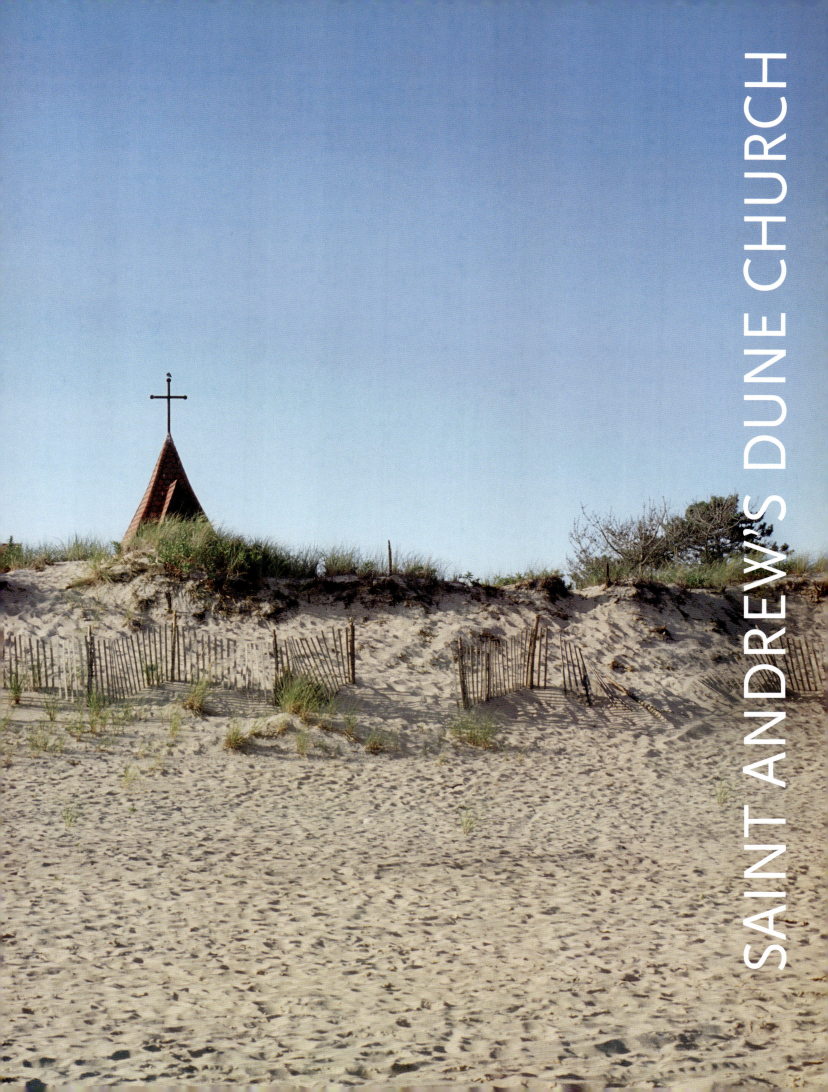

SAINT ANDREW'S DUNE CHURCH

For more than 125 years, the shingle-clad church on the beach has survived the sea's fury and has been an integral part of the spiritual life of Southampton, Long Island.

Up on the dunes, past the ponds and privets of Southampton, is a church that has outlasted storm and surge. It is called, appropriately, Saint Andrew's Dune Church, and for a century and a half it has been a place where souls are saved, one way or another.

For fifteen summer Sundays, the doors of Saint Andrew's Dune Church are opened to the elements that have shaped it. Bells peal out as parishioners arrive. Some are grandchildren and great- (even great-great-) grandchildren of the founding congregation; others are newcomers to the longtime Southampton churchgoing ritual.

Time has stopped in this church. The hymnals are from 1940, not later. The flag is one that soldiers brought back after World War I. A Tiffany pocket watch sits on the pulpit rail to clock the passing minutes of the sermon. The original structure was built in 1851 as a volunteer lifesaving station, part of a network constructed along the Atlantic Coast. Less than thirty years later, though, it was abandoned when the United States Life Saving Service got a new building nearby. In 1879, Dr. T. Gaillard Thomas bought the old station for a church, which was then moved to land donated by another summer resident, C. Wyllys Betts. That the purpose went from physical salvation to spiritual is not lost on the Reverend Peter M. Larsen, under whose care this church falls. "This was once a lifesaving station, and it continues to be one today," he says. The church is on the dunes, across from Agawam Lake, which was where the early Southampton residents built their houses. Many Sunday worshippers sailed or rowed to church. "One woman," Larsen says, "came by gondola."

The exterior is clad in red shingles with green-trimmed windows. The roof is fish-scale shingles. There are two towers and a "lantern"—a cupola that sheds light below. Inside, the ceiling is dark wood, deepened over the decades. The pews are original, from 1879. On the walls are tablets that recount Southampton history, starting with its settlement in 1640 under a land grant from William Alexander, earl of Stirling.

At least ten of the stained-glass windows are by Louis Comfort Tiffany, who began working with glass at the time the church was incorporated. These windows are often cited as being among his masterworks. One depicts Sir Galahad and is particularly opalescent, showing the techniques that Tiffany perfected around the turn of the last century.

The sea has always afforded a powerful religious metaphor. At Saint Andrew's Dune Church, it is the essence of the experience. The sea is always present, and the walls are inscribed with biblical passages that recall it. From Psalm 77: "Thy way was in the sea, and Thy path in the great waters, and Thy footsteps were not known."

The infamous 1938 hurricane ravaged the church, destroying walls and windows—including two by Tiffany—and filling the sanctuary with sand, giving new meaning to another biblical inscription: "Thou rulest the raging of the seas. Thou stillest the waves thereof when they arise." After much debate about moving inland, the congregation chose to rebuild, but the sea has continued its inexorable course. In 1995, the church was moved to the parking lot, then returned to a new foundation, bolted to piles set deep into the ground, and secured against wind and waters.

And indeed those elements are very much a part of this church. On a given summer Sunday, light filters in gently through yellow-hued clerestories. The sound of the ocean is a backdrop. There is a slow processional for Communion, the church quiet and the organ soft, as if each worshipper is connecting with the place and more, with something vast. Then comes the closing hymn, and the congregation sings: "Jesus calls us o'er the tumult of our life's wild, restless sea." Later, Larsen, looking upward to the rafters where longboats and oilskins were once stored, can feel the weight of the church's history. "I like to think there are a lot of spirits up there," he says. In the background, there is the sound of the surf.

ABOVE: The church is wreathed in flowers and plants. Doors are left open to the sea air during Sunday services.
OPPOSITE PAGE: A luminous, delicately colored stained-glass window, one of several that Louis Comfort Tiffany made for the church, survived the horrific 1938 hurricane.

GETHSEMANE EPISCOPAL CATHEDRAL

An austerely elegant cathedral in Fargo, North Dakota, looks at home on the prairie and is a refuge from the area's severe climate.

The tall, distinctive bell tower of Gethsemane Episcopal Cathedral gleams like a beacon on the flat plains of Fargo, North Dakota, a place where long winters and harsh winds call for a strong counterforce of faith. Ethereal but sturdy, the tri-level tower suggests a grain elevator where a harvest of souls might be stored. Although the whitewashed board-and-batten structure is a startling departure from the traditional stone cathedrals of the Great Plains, there is a comforting familiarity to its outlines. And while Gethsemane appears completely at home in its Dakota setting, it is also profoundly modern in conception and design—the result of a remarkable collaboration between a well-known, venturesome team of architects, Charles Moore and Arthur Andersson, and a congregation willing to take chances.

Gethsemane is actually a new incarnation of an older cathedral. When the original stone building in downtown Fargo caught fire in 1989, the congregation salvaged what it could. The pews, miraculously, had not been damaged, and portions of the stained-glass windows were still intact. A line from T. S. Eliot's *The Waste Land* seemed to apply: "These fragments I have shored against my ruins." It was difficult at first for the grieving congregation even to think about rebuilding, much less to consider that its cherished cathedral might rise in a new place and in a new and bolder form.

As the church members settled into temporary quarters in a warehouse-like building south of town, they soon came to realize how much their worship had depended on a special, sacred space. Gethsemane, they knew, wasn't cut out to be a storefront kind of church. "It was claustrophobic," recalls Rev. Frank Clark, who was dean of the cathedral in the 1990s. "Our liturgy is very sensory, and light is very important to us. There is a sense of time of day and time of year and the kind of light that comes in. And we live in a latitude that is particularly sensitive to the length of day and changes in light."

Huddled in their harshly lit, makeshift church, the congregation made two key decisions. The first was to move to a tract on the prairie several miles south of downtown, near new subdivisions where most of Fargo's growth was taking place. "That was a pretty wild idea," says Marian Prior, who has served for decades in the educational work of the church. In recent years, a number of churches began to settle into the neighborhood, and that once lonely stretch of south Fargo now resembles a kind of campus of religious diversity.

The second major decision was to find an architect of consequence. "We wanted a building that would stand out," says Clark. "We wanted architecture that fit the area, but we wanted it to be noticeable." The church members also had to overcome the Episcopal bent for quiet decorum and do something bold and beautiful that would beckon potential new members. Just as important,

GETHSEMANE EPISCOPAL CATHEDRAL

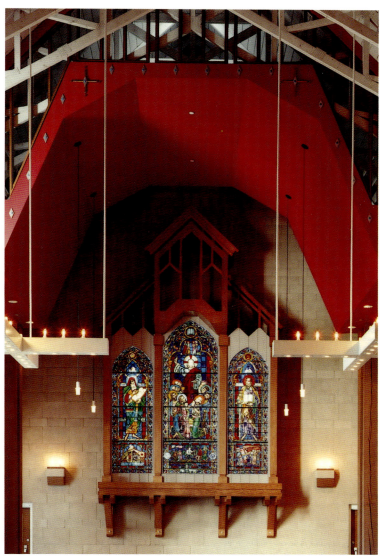

ABOVE LEFT: The Bible, which is opened to a chapter in the Old Testament, sits on an eagle lectern.
ABOVE RIGHT: In the sanctuary, lighting fixtures of intersecting beams hang from long rods. There are recessed lights on the underside and candle-like bulbs on top.
OPPOSITE PAGE: Parishioners are understandably fond of calling the cathedral style "prairie Gothic."

though, they wanted to build a "church home," as Prior puts it—a building in keeping with their vision of their mission and their identity as a church and as a community.

Although no one had seen a building designed by Charles Moore and his younger partner, Arthur Andersson, who were based in Austin, Texas, they were impressed by the collaborative way their firm worked with clients. Somewhat frail, Moore (who died in 1993) was intrigued by the idea of building a cathedral from the ground up. As Moore's health worsened, Andersson, who has family ties to the Dakotas, took over even more of the design process.

Moore's penchant for whimsy and fractured classicism (evident in the Wonderwall at the 1984 New Orleans World's Fair) was transmuted in Gethsemane by the dramatically somber setting of the Great Plains and by the collective dreams and ideas drawn from the congregation. "It was a process of healing for the church and of discovery for us as architects," Andersson says. During four months of workshops, he and Moore learned about the needs and leanings of the congregation. As the headquarters of the state diocese, the building would include offices for the bishop. As a school during the day, it would have to house several classrooms.

"They encouraged us to come up with our wildest ideas," recalls Harry Hawken, who worked on the building committee. The need for storage space for chairs, for example, resulted in exterior buttresses that jut out from the great hall. There was a suggestion for a chapel for more intimate gatherings.

As conceived by the architects, the tiny chapel, with its high walls and narrow space, hidden beyond the main sanctuary, has a particularly medieval feel, an impression reinforced by its opening onto a cloistered courtyard. Bright red-and-blue support beams offer pedestals for statuary. The courtyard, an unthinkable frill in North Dakota's severe climate, was Moore's most controversial suggestion to the planning committee, says Andersson. But the light it would afford through large windows to adjoining rooms and walkways won over skeptical congregants.

During the design process, the architects constructed pull-apart models that church members could rearrange in various configurations. The bell tower, for example, kept shifting its position until it wound up above the entrance vestibule. There, as a prelude to the narthex, it suggests a comfortable balance between the formal worship space of the sanctuary to the right and the more informal fellowship space of the great hall to the left. The sanctuary and the great hall are divided by transparent screens, a mere illusion of boundary, that can be retracted to extend the sanctuary for special occasions.

Church members like to refer to the style that resulted as "prairie Gothic." The cathedral's rather stark white exterior, which can take on an otherworldly lightness in the snow, contrasts with the substantial stone-colored walls of the interior, warmed by stained glass and other rich accents of color. Budget constraints dictated poured concrete blocks rather than real stone for inner walls and floors, although a subtle pinkish-gold tint added to the mix lends a soft glow to the surface, suggesting that worshippers are surrounded by buffed stone rather than mere concrete.

For accent as well as acoustics, the architects added a rich red canopy of painted gypsum wallboard, which they refer to as a "cloud cover," stretched beneath the skylights, barnlike beams, and scissors trusses supporting the roof. Along the far end of the great hall is what Moore called a "memory palace," decorated by stained-glass windows from the old church. New windows depict the church's history, beginning with early meetings more than a century ago in a railroad car, the new building rising up as the latest stage in the saga.

Despite the austere elegance of its outlines, Gethsemane radiates a sense of warmth, of shelter from the storm, and of food for the soul. It's the kind of place that lifts your spirits. As Marian Prior says, "The biggest lesson that we got was that it doesn't hurt to dream. This was a dream that worked. When I look at the church, I think, *This is who we are.*" For all its startling boldness, the cathedral suggests a building strongly rooted in the needs, experiences, and aspirations of its worshippers.

OPPOSITE PAGE: A tiny, almost medieval chapel beyond the sanctuary has brightly colored support beams and opens onto a cloistered courtyard.

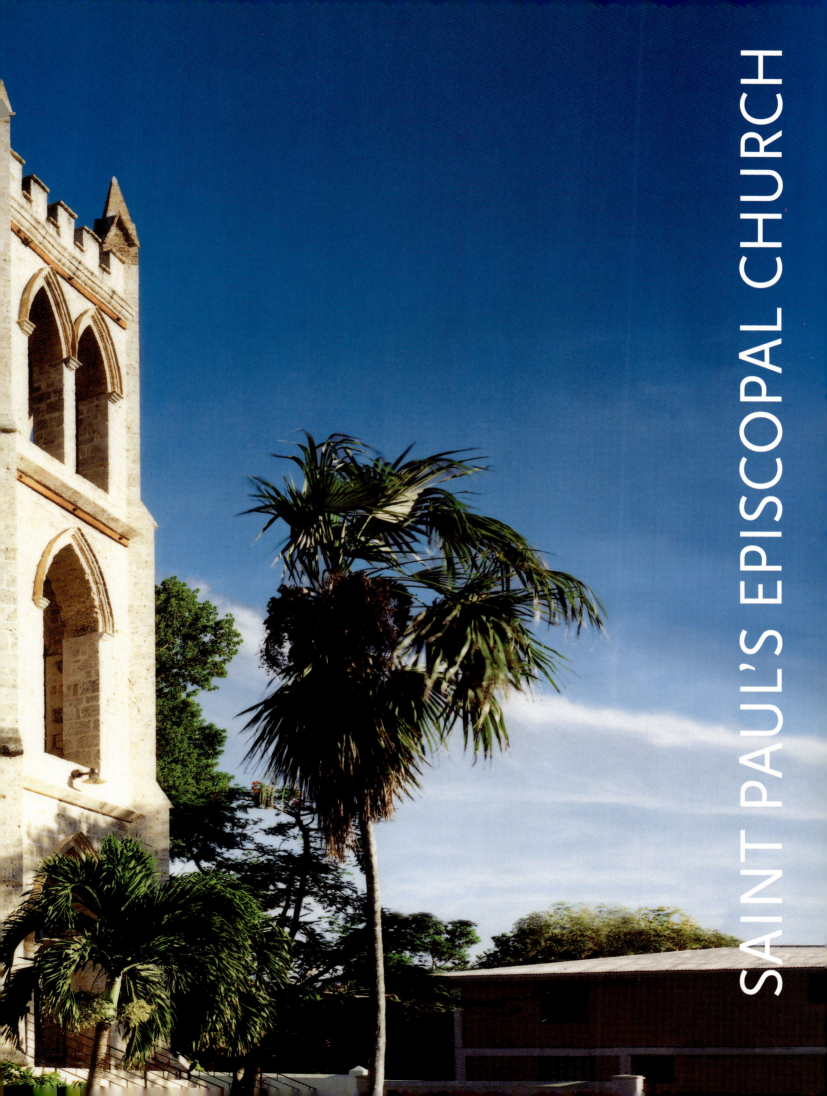

SAINT PAUL'S EPISCOPAL CHURCH

After a devastating fire, a determined St. Croix congregation rebuilds its historic limestone neoclassical church that invokes Caribbean arts and crafts.

PREVIOUS PAGES: A neo-Gothic bell tower of local limestone serves as the formal entrance to the church. It was added in 1848 to commemorate the freeing of the island's slaves.
OPPOSITE PAGE: A stained-glass window of Saint Paul is directly behind the altar. Working from photographs supplied by parishioners, Jack Cushen was able to make this replacement for the original, which was destroyed in the fire.

Officially, it is Saint Paul's Episcopal Church, but it is called the English Church, a name that speaks of both time and place. It is a simple, neoclassical structure with an equally simple neo-Gothic bell tower, and a surpassing dignity and elegance. Built in 1812 for the English planters living in Danish-owned St. Croix, the church endured volatile man-made history and treacherous hurricanes, only to suffer a fire so ferocious that almost all that remained were the thick walls of coral rock and brick and the galvanized sheet-metal roof.

"In the end, Saint Paul's was too important not to save," says William Anglin Taylor, the architect who oversaw its restoration. Today, Saint Paul's is whole again, risen quite literally out of the ashes. Its ceiling is the pale blue favored by some church architects in the late-eighteenth and early-nineteenth centuries. Caribbean trade winds waft through mahogany louvered windows—the same mahogany that has grown in St. Croix for centuries. If the church's accoutrements are all new, they are true.

The fire broke out on the night of January 8, 1996, and burned so fiercely that it melted stained-glass panels. Restoration required both historiography and detective work, as scant records existed. Taylor, an architect who is also coauthor of *The Historic Churches of the Virgin Islands*, searched for clues as he trudged through ashes a foot deep. He laid hundreds of shards of the stone prayer tablets on wood tables to see how Bible passages were divided. To get an accurate sense of details, he scrutinized hundreds of photos of weddings, baptisms, and confirmations, and prodded elderly church members for their memories.

The restored church relies on much of what Taylor terms the "collective memory" of the congregation, but it also invokes the art and craft of many Caribbean islands. Masons and millwrights competed to see whose work could be the finest. Mahogany timbers were cut for such elements as the beams, balusters, pews, windows, and shutters. Local limestone that had been used in the bell tower was discovered lying by a roadside, so the missing pieces were easily replaced.

Other elements of the church had originally been imported, and were again. The heart pine flooring arrived from the Carolinas, just as it had in 1812. Wrought-iron hinges and brackets came from Cassidy Bros. Forge, in Massachusetts. Dick Reid, a stone carver in England whose restoration work has included Windsor Castle, created new prayer tablets and the pulpit. From parishioners' photos, stained-glass scholar and restorer Jack Cushen of East Marion, New York, was able to discern the scenes of a large arched window whose center panel showed Saint Paul surrounded by soldiers and disciples. The redone stained glass adds to the group Elisha Daniel Sr., Saint Paul's longtime

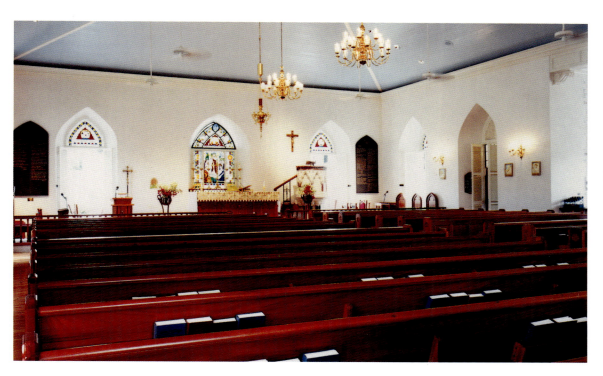

warden, who was baptized, confirmed, and married in the church, and who devotedly saw it through the entire restoration process.

For the carved wood, much of which would be copied from the originals, Taylor turned to Demetrius Klitsas, a master woodworker from Massachusetts. For the altars, however, Taylor asked a local artist, Jeri Hillis, to draw a template for Klitsas, with Caribbean foliage rather than the English flora of the original. Stylized carvings of sea grape, ginger Thomas, coconut palm, mahogany, bird-of-paradise, and banana leaves now adorn the altars.

One can picture Saint Paul's original architect, anonymous today, armed with Isaac Ware's books of Palladio and a set of mathematical rules. The church is at once sophisticated and primitive, its strict proportions adhering to the Palladian ideal that informed so much English architecture of the time. "It is actually typical of a Caribbean great house, with its basic proportions and three-part symmetry," Taylor says. "The golden mean was the starting point." And as in a Caribbean great house, the windows— covered only with mahogany shutters—fling open to let air in and sounds of worship out. Each arched window has its own spring point and dimensions. Despite the formal proportions, the church is a mix of precision and improvisation.

In 1848, Denmark abolished slavery, and the island was integrated beyond the imaginings of those outside the Caribbean. To commemorate abolition, Saint Paul's added a bell tower of native stone, but in the neo-Gothic style that had become popular. The tower is the church's formal entrance and is used for wedding and funeral processions, but on a given Sunday the parishioners stream through side doors. After the bell tower went up, the church was fully integrated, and has been ever since. Eventually, the balconies where blacks used to sit came down. When the United States bought the Virgin Islands in 1917, the American Episcopal Church faced its own quandary, as mainland churches weren't integrated. "The church in St. Croix offered a paradigm for the equality of heaven as seen on earth," Taylor says. "At some point, God takes over and says, These are all my children."

ABOVE: The pale blue ceiling is typical of many churches of the period. Pews, shutters, and other elements are made of local mahogany, just as they were originally.
OPPOSITE PAGE: Arched doorways of the rebuilt church stand open for worshippers.

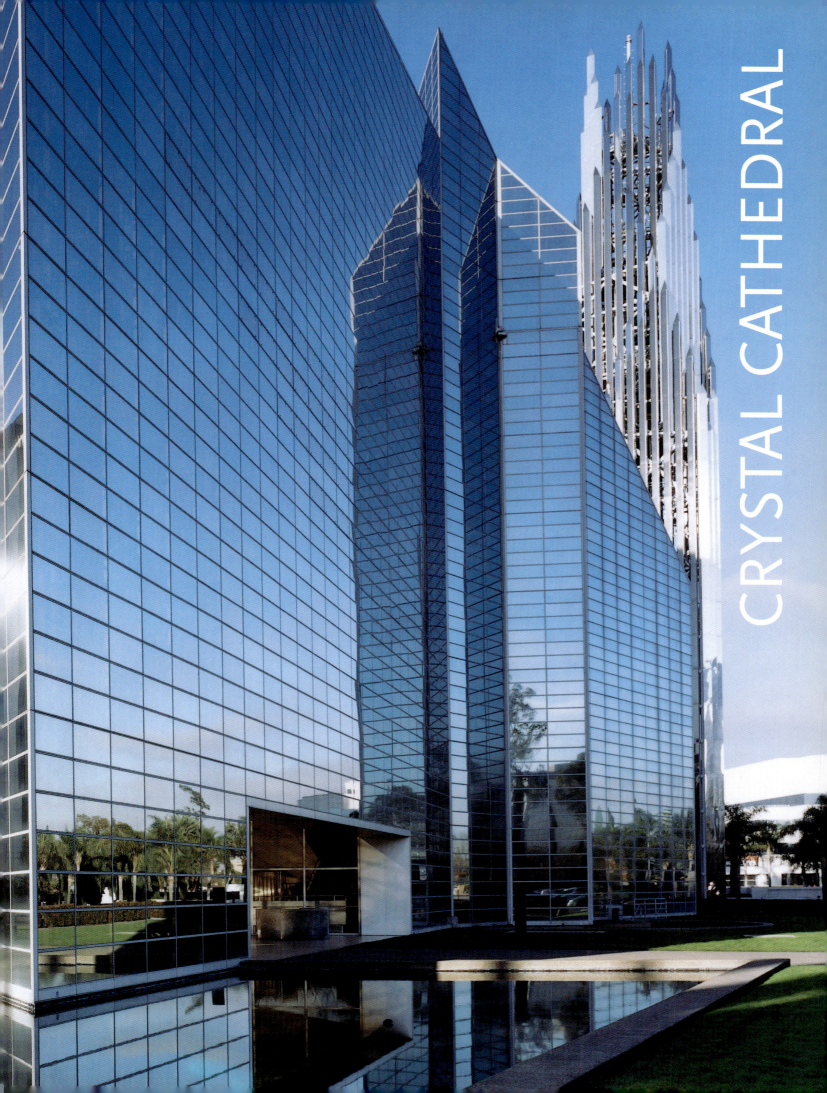

CRYSTAL CATHEDRAL

Robert H. Schuller changed the face of worship with his *Hour of Power* telecasts, and persuaded three great American architects to design buildings for his campus in Garden Grove, California.

Almost every architect yearns to design one great room, but few ever do. "This is mine," the late Philip Johnson once said of the soaring, light-infused sanctuary he designed for the Crystal Cathedral in Garden Grove, California. For some years after it was dedicated in 1980, this virtuoso space became almost as symbolic of Johnson's work as his own tiny transparent house, both of them in very different ways groundbreaking in their use of glass.

The Crystal Cathedral pays homage to architecture in ways that are both obvious and little known. The "cathedral" itself is among the most famous churches in America, not just because it was designed by Johnson—who died in 2005 at the age of 98 after a career that made him the most renowned of all American architects of that period—but because of its role as the home of the *Hour of Power* television broadcasts.

What is seldom noted is that the Crystal Cathedral is only one piece of a grouping of important works of architecture that span three generations. The first are buildings and gardens by Richard Neutra, the California modernist. Then came Johnson. The most recent building was designed by Richard Meier. "And," says Dr. Robert H. Schuller, the founding pastor and patron of all this, "I never once lowered the level of architectural sophistication."

And sophisticated it all is. As you enter the complex, the Neutra buildings are on the left; they are surprisingly compelling, especially considering the bravura architecture that is to follow. The buildings—there are three by Neutra, set around a courtyard water garden—are studies in glass and stone, primarily. The stone is set vertically, counterintuitively, to be sure that all know that this is architecture and not a remnant of nature. Neutra's buildings set the standard in that respect, at once part of and separate from the environment. That duality set the standard for Johnson, whose Crystal Cathedral is not only iconic but visible from miles away on the freeways, and, much later, for Meier.

Schuller arrived in Orange County in 1955 as a 28-year-old Dutch Reformed minister with a young family and no place to preach, but he had both the will to build one and a calling. Of necessity rather than novelty, he found his first church in a drive-in movie theater and preached to parishioners who were sitting in their cars. Those were heady times in fast-growing southern California, where new suburbs held the promise of the American dream for newly married World War II veterans. Schuller recalls smelling smoke in the air as he and his wife drove into Garden Grove—it was orange trees being burned to make way for Walt Disney's new amusement park at Anaheim, which like his televised ministry became an icon of American life in the last half-century.

Schuller went on to build an expansive complex to accommodate his huge, ever-growing congregation and express his ideas about the human need to

worship in places of beauty and tranquillity. He calls the array of architecture he has assembled "these masterpieces" and regards, not incorrectly, his building legacy as a small museum.

As an Iowa farm boy, he did his share of stargazing, and he knows that the open spaces and the beauty of blue skies over hay fields affected him in a profound way. He began to give voice to this when, in the late 1950s, he met Neutra. "I had a good college education," Schuller says, "so I never expected to learn so much from an architect that would so affect my theology, so affect my teaching." Neutra built a sanctuary and, later, a tower with a chapel atop it. The sanctuary—which is still used for special services and events—has one wall composed of huge industrial glass windows that would swing open on Sundays to connect to the parking lot, which through those early decades filled with drive-in worshippers. The Tower of Hope, as it is called, was dedicated in 1968, two years before Neutra's death. From the rooftop chapel you can see Disneyland and, on clear days, the Pacific Ocean.

Schuller had just begun. Friends suggested that his next architect be Eero Saarinen, but Schuller says now that he found Saarinen's work to have "too much brick." On a flight back from Europe, the minister, already famous for his widely televised *Hour of Power,* read an article about "ten beautiful places you must see," including Johnson's Water Garden in Fort Worth, Texas. Schuller gave him a call without any real idea of who he was, or vice versa. "I told Johnson I had worked with Neutra for many years," he says. "He thought I'd been a draftsman there, but he agreed to see me anyway. We hit it off pretty quickly."

Soon Johnson had designed a soaring cathedral, but he proposed solid walls. Schuller told him that he wanted an all-glass building, but Johnson said that would be unaffordable. Schuller said he'd raise the money. He did.

The day the sanctuary was dedicated, the entire congregation filed from the Neutra building to the new one. Clara Landrus, who started as a parishioner at the drive-in church (she and her late husband, Wilfred, a college professor, first worshipped there in their '49 Chevy), remembers the excitement, especially marveling "at the spaciousness and the quality of light" in the Crystal Cathedral. Ever since, those who have seen it—worshippers, visitors, and television viewers (an estimated 20 million of them every Sunday)—have found it a place of wonderment.

At the dedication, Johnson said there is a "greater aim an architect can have, and that is to build a building that isn't materialistic, that isn't built for men but built for God. We believe that is what we're on earth for, to create shapes and space like this." Later he designed the far more Gothic-inspired campanile that sits beside the sanctuary.

Even then, Schuller was not finished building. He met Richard Meier and began talking to him about the need for a visitors' center. "I'll do it," said Meier, who points out that the Neutra buildings are basically rectangles, while the Johnson cathedral is a triangle. Thus, his is a circle. "Each building had a separate and unique geometry," he says. "This completed the ensemble."

More important, Meier's building—it is stainless steel and glass, including a dramatic curved glass block wall that allows this interior, too, to be suffused with sunlight—transforms the complex into a campus, linking the buildings both physically and visually. And it stands on its own, while paying homage to the others, particularly to the Crystal Cathedral itself. "I think it's one of Johnson's best works, quite frankly," Meier says. "I've been up on the pulpit on a Sunday, and whether there are three hundred or two thousand people, it seems intimate. And you really feel the quality of the light. Philip always talked about how he loved Chartres. I think this is his."

ISLAMIC CULTURAL CENTER

Because the Islamic center on Manhattan's Upper East Side serves the faithful from many cultures and traditions, its design emphazies geometry, a language shared by all.

Every religion has its own iconography of numbers. But the Islamic Cultural Center of New York, designed by Skidmore, Owings & Merrill and completed in 1991, seems in many essential ways to be about the math. That's not just because the faith dictates five sets of prayers a day, or because the congregational space (for the more formal Friday service) at the center's heart is a perfect 90-foot cube, or because eight of the 99 attributes of Allah are spelled out in squared-off Kufic script in the cap of the mosque's perfect half-sphere dome. It's not even because the 90 pinpoint lamps descending from the dome's base trace a shimmering circle of light in easy 40-degree sections above the mosque floor, or because much of math as we know it coincides with Islam's flowering.

Commissioned in 1985 by a consortium of United Nations countries, led by Kuwait, whose permanent representative to the U.N. is the chairperson of the center's board, the Islamic Cultural Center serves an unusually diverse group: representatives from all of the U.N.'s 57 mostly Islamic member nations as well as the faithful from the New York metropolitan area. From the outset, the design of the center, Manhattan's only mosque built as such to date, was freighted with added significance. "It had to represent Islam to the United States in a positive way," SOM partner Mustafa K. Abadan says, "and it had to relate to its users and the different expectations of their different traditions. It was also very important to create a place of worship that was forward-looking, for New York, at the end of the twentieth century." Formulating any calculus that synthesizes the traditional and the modern is never easy, but here the challenge was especially complex because two advisory groups—one of congregation members active in religious and civic affairs, the other of academicians and well-known Islamic scholars—weighed in on every design decision.

Mosque architecture differs widely from culture to culture and country to country: consider the Alhambra, the Dome of the Rock, and the Suleymaniye mosque, for example. "In essence," Abadan says, "any single person who chooses a clean place and faces Mecca can pray there, and that will constitute a sacred place. The tradition of the mosque developed out of people coming together." The few givens of mosque design—established, according to legend, in Muhammad's seventh-century Medina courtyard—include the location of the mihrab (or prayer niche) on the qibla (the Mecca-facing direction), with the minbar (pulpit) to the right. The minbar, Abadan says, "incorporates the stair seat for the imam and the platform for the sermon. The symbolism goes back to the staircase to the Almighty: the imam always sits one step below the final one, which is always reserved for the Almighty."

A monolithic, domed structure with a grand plaza (the minaret, by Swanke Hayden Connell Architects, was added in 1992), the center is a kind of city of Allah, a complex of secular and religious spaces that occupies a significant portion of a city block on the verge of East Harlem. The secular part of the building follows the Manhattan grid, while the religious part conforms to the geometry of Mecca and is off the city grid. When weather permits, the congregation moves outdoors for the holidays. "We were asked to create a place of worship that allows all Islamic nations to feel a part of it," Abadan says. "The design relies completely on geometry, geometry in its most idealized and fundamental forms—the square, the intersections of the square and the circle—to create stability, unity, and harmony."

The center's stone-clad exterior disguises what is actually a twentieth-century steel building. "Every place where we felt the expression of a masonry structure would have force, we used panels with glass," Abadan says. So whether you enter the mosque's prayer space from the street, through 15-foot-high bronze doors that open at the touch of a fingertip, or from the building interior, you shed the world at a threshold of light. The glory of that light is the mosque interior's greatest surprise and its greatest gift, a fact acknowledged at the base of the dome with scriptures from the Koran that refer, according to Abadan, to the guiding role of Allah through light in mankind's pursuit of happiness—and the mediating role it plays between traditional and contemporary elements in this design.

Because the sexes pray separately, the architects suspended a women's balcony from steel trusses. "We chose the balcony," adds Abadan, "because it allowed the women the equality of horizontal spread, plus privacy." The mosque interior divides into thirds, a physical and metaphysical trinity of sorts. "The lower part is intended to disassociate congregants from the city," says Abadan. "There's light, but no noise, and the space is inward oriented. The clerestory in the middle section reconnects you to the world, to today. The dome is an uplifting element, connecting the human with the Almighty." The windows' geometric decorations are baked-on paint.

Each of the center's member nations contributed funds or gifts in kind. Tiles from Turkey line the downstairs room currently used for the five daily prayers and the center's Sunday school (which will revert to its original, multipurpose role when the rectory and school, now under construction, are completed). The mosque's carpet, a gift from Pakistan, is an SOM contemporary design in traditional colors—including green, which, Abadan says, "represents paradise in Islam"—and was woven in sections overseas and assembled in the United States. The ebony benches, for one-on-one instruction or for studying the Koran when the mosque is not in use, are Indonesia's offering.

Finally, there's this algorithm of sorts: Medina, 622 A.D.; Cedar Rapids, Iowa, 1934; Manhattan, 1991. Not a Fibonacci series, true, but it is a sketch of Islam's expanding spiral from its original house of worship to America's first built-for-the-purpose mosque, on the prairie, to SOM's remarkable work of contemporary religious architecture on polyglot and pancultural Manhattan's Upper East Side.

PREVIOUS PAGE LEFT: The mosque's interior is a delicate balance of traditionalism and modernism. A perfect light-filled cube, it contains a suspended balcony for the women because the sexes worship separately.
PREVIOUS PAGE RIGHT: The minbar, or pulpit, derives from the staircase to the Almighty. It includes a platform for the sermon and the imam's seat, always one step from the top.
OPPOSITE PAGE: The base of the dome contains scriptures from the Koran that emphasize Allah's role in guiding light and happiness to humanity.

BRIGHAM CITY TABERNACLE

PROVO TABERNACLE

Two nineteenth-century tabernacles in Utah are testaments to the faith, strength, and artistry of the Mormon settlers who built them.

As you stand in the ancient, stunning countryside of central Utah, it's easy to forget just how young the Mormon religion is. The Church of Jesus Christ of Latter-Day Saints, as it is officially known, was founded by Joseph Smith Jr. in upstate New York in 1830. The first pioneers arrived in Salt Lake City in 1847, and the denomination is as powerfully associated with the area as Catholicism is with Rome. "Maybe religion is so strong in this landscape because this is terrain which puts the human in his place in a way Manhattan never could," Australian Thomas Keneally wrote in his fine book *The Place Where Souls Are Born*. "You can come to a place like the Wasatch Mountains or the Great Salt Basin to learn your true scale."

The early Mormon pioneers, many of whom fled west to escape persecution, built chapels or meetinghouses, which often served double duty as schools. As settlers put down roots, they also began erecting tabernacles, which were bigger than chapels but not as significant as temples. The tabernacles were designed not for weekly services but to accommodate periodic meetings of several stakes—groups of wards, as Latter-Day Saints congregations are known—from a wide area.

Many tabernacles, made obsolete by the building of more spacious chapels in the twentieth century, have been torn down or sold, but some handsome ones remain, including one in Brigham City that was dedicated in 1890 and one in Provo that was dedicated in 1885. "The tabernacles were the cathedrals of the desert, evoking early Europe when there were hovels around a cathedral," LDS archivist Scott Christensen says. "I'm sure that's how it seemed to the people then: it was the best they could build." Unlike the massive cathedrals of Europe, these tabernacles are pared down, with no altar, font, or statuary, no kneelers, candles, paintings, or side chapels. The most notable absence is a cross. "For us," Gordon B. Hinckley, president of the church, has said, "the cross is the symbol of the dying Christ, while our message is a declaration of the living Christ."

There is great beauty in the simplicity of the Brigham City and Provo tabernacles, in their craftsmanship and details and especially in the knowledge of who built them and how. The tabernacles were constructed by members of the church, sometimes in exchange for the food and shelter the church provided them. There were skilled craftsmen among them. "Mormon missionaries in nineteenth-century Europe had success with blue-collar people," Christensen says, "so stepping right off the wagon was a fourth-generation stonemason or carpenter, and we had the advantage of all that experience."

The interior of both the Brigham City and Provo tabernacles, like those of many great concert halls, is shaped like a shoe box. A central aisle, flanked by long rows of benches, leads to a podium, with banks of seats for the choir behind it

and organ pipes rising against the back wall. It was Brigham Young himself, the second president of the church, who chose the hilltop site for the Brigham City tabernacle, which is built of local stone. The interior was rebuilt after a fire in 1896, and renovated in 1986. One of the most striking features is a pair of curved wooden banisters on the stairs that flank the podium and link the first floor and the gallery, whose wooden facades have handsome carved quatrefoil medallions. "Each banister is one piece of wood, twenty-five or thirty feet long," says Willie Hunsaker, who has been looking after the building for 30 years and is its gregarious, unofficial historian. The tabernacle builders had little money but plenty of ingenuity. "It takes heat and moisture to bend wood," Hunsaker says, "so they made two banisters, wound wire around them, and put them in a manure pile. Every day they'd take them out, twist the wire, and put them back in the manure." Eventually, the workers got precisely the bend they wanted. "I think it was a job of love," Hunsaker says.

Devotion is also evident in the satiny wood benches, which appear to be made of well-waxed oak. In fact, this is modest trompe l'oeil, with an underlying layer of homesickness. "There's fir and pine around here," Hunsaker says, "not plentiful hardwood. They painted the wood to look like oak because that's what they knew and loved from the East." History is visible throughout the tabernacle (which is open for tours from May to late September). Underneath the stairs, you can still see an old raceway for water, which pumped the organ bellows. "It worked fine till winter came," Hunsaker says. In the other direction, between the ceiling and the sharply sloping roof, charred ends of a few beams remain, survivors of fire more than a century ago.

The Victorian tabernacle in the center of Provo also has a storied past. In 1885, while the building was under construction, former president Ulysses S. Grant died. People in the community wanted to hold a service in his honor, and chose the tabernacle for the site. "They had to put down floorboards, and two thousand people crammed in," Scott Christensen says. The door and windows had not been installed, but the assembly was "probably grateful for the ventilation, since it was August." For decades the tabernacle was also used as a performance space, and among the great artists who appeared there were bass-baritone Paul Robeson and composer-pianist Sergei Rachmaninoff, who allegedly stopped playing, midphrase, until a train passed by.

The building became all but uninhabitable by 1915 because a heavy central tower was causing the roof to sag dangerously. The tower was removed and the building saved. Two important symbols of the Mormon faith dominate. The beehive—which stands for the industriousness of the church members—appears as sculptures outside the entrances and in the delicately colored stained-glass windows. The sego lily appears throughout the church, in carvings and in the windows. "Sego lilies saved the Mormons from starving," during droughts and their first winters in Salt Lake, Christensen explains.

Roots are powerful, and anger over the destruction of some old tabernacles ensures the survival of ones like these. And, as Christensen says, "everyone has a grandma or grandpa who worked on one." Non-Mormon visitors might wonder why the tabernacles were "dedicated" not at their completion but perhaps years later. "A building must be completely paid for before it can be dedicated," Willie Hunsaker says. "It's dedicated to the Lord. You can't give the Lord something you don't own; you can't put the Lord in debt." It's a principle that should resonate with everyone.

PREVIOUS PAGE LEFT:
Fine, delicately colored egg-and-dart molding runs beneath the ceiling in Brigham City.
PREVIOUS PAGE RIGHT:
The quatrefoil medallions carved in woodwork throughout the Brigham City tabernacle are matched in the deep-red wool carpet. "Only tabernacles and temples have carpeting," Willie Hunsaker says, "so we take good care of it."
OPPOSITE PAGE:
Local craftspeople built the Provo tabernacle. God is definitely in the details, including the elaborate, beautiful carving.
FOLLOWING PAGES: The deep, wide platform in the Provo building can also serve as a performance space.

ENMANJI BUDDHIST TEMPLE

Since the Depression, a twelfth-century-style Japanese temple has offered solace and inspiration in Sebastopol, California.

The Enmanji Buddhist temple is tucked behind a chain-link fence on Highway 116, the road to Sebastopol, California. Should you notice it—amid the feed stores, taco stands, barbecue joints, and garden centers—the temple will transport you to another time and place, as it should. In this hardscrabble landscape, it is a particularly striking sight, a twelfth-century Kamakura-period Japanese temple. Instinctively, you know that there is a story to be told here.

The Enmanji temple is a keeper of culture. Amid the elegant hand-painted motifs of lotus flowers, chrysanthemums, and dragons is a darkened shadow on the ceiling. It has been there since the height of World War II's anti-Japanese emotions, when the temple was set on fire. Through six decades of upkeep, the mark of smoke has not been erased—a sober reminder of those years when Japanese-Americans were sent to internment camps.

The name Enmanji is full of symbolism and even a bit of wordplay. In English, it means "fulfilled garden temple"; in Japanese, the characters also read as "so-no-ma-te-ra"—a play on its location, in Sonoma. The name, says Enmanji's minister, the Reverend Carol Himaka, had to be specially granted from the home temple in Kyoto.

The story begins in Japan, where the temple was built as a faithful rendition of a centuries-old style. Then it was dismantled and shipped across the Pacific to become the Japanese-owned South Manchurian Railway exhibition hall at the 1933 Century of Progress Exposition in Chicago. There, Japanese craftsmen reconstructed the wooden temple, which was made in the traditional way, mitered and without any nails ("like Lincoln Logs," Himaka says).

When the fair ended, a new home was sought for the temple. At the time, Sonoma County counted about 450 Japanese residents, many of whom had arrived in the 1880s. Most were Buddhist and had no place to worship. Sebastopol was chosen, and $10,000 was raised to transport the temple. It was dedicated on April 15, 1934, the day they celebrated as the Buddha's birthday. Accounts of the dedication are colorful, describing a procession of 150 children dressed in traditional kimonos and carrying pink and white lotus flowers, along with another procession of white-robed young men carrying an altar aloft.

During those early years, worshippers traveled down narrow, hilly rural roads from distant points of Sonoma and neighboring counties. Even today, Enmanji draws some of its congregation from afar, as it is the northernmost temple of the Buddhist Church of California.

The wooden temple has a metal roof—the only real deviation from authenticity, Himaka says, noting that in Japan it would have been tile—that curves gracefully over white wooden walls. The walls and ceiling feature delicate painted motifs. "There's a mix of Chinese and Japanese here," says

PREVIOUS PAGES: A small Japanese garden flanks the entrance of the temple.
OPPOSITE PAGE: Though the temple itself is spare and simple, the altar is not. It was hand-carved and gilded in Japan but installed well after the temple was established in Sebastopol. Temple members, most of whom were agricultural workers in those early years, raised the money for it.

88

Himaka. The chrysanthemum is the symbol of the imperial family, and the lotus flower is traditional to Japanese Buddhism. The dragons depicted throughout are more often found in Chinese painting. The intricate gilded and brightly painted altar was sent from Japan. "It's amazing," Himaka says, "that these early settlers, the Japanese immigrants, were able to do this with what they had."

After the war, the temple became a major cultural center for the region. It was used, Himaka says, for monthly showings of films from Japan. It also became the home of the annual Chicken Teriyaki Barbecue, now in its fifty-second year. Temple members cook the much-prized local Petaluma chicken for visitors who travel for miles to attend. A week later, the temple holds a second celebration, Obon. Though it is a religious commemoration of ancestors, it is a happy event that features a day's worth of traditional dancing (open to anyone who practices for a week), Taiko performances, and a noodle dinner.

Enmanji's history is contained in part in clippings and documents, but also in the recorded memories of early members, published as part of an ambitious oral history project of the Sonoma County Japanese American Citizens League. "The most terrible thing that I recall happening was to our temple," Dorothy Shimizu said in a 2003 interview, describing the wartime acts of vandalism in which teenagers took an ax to the wooden columns and tried unsuccessfully to burn down the building. After that, members of the nearby Congregational Church's youth group took up watch to protect it.

By now, younger members are many generations removed from Japan and its traditions, and, as Himaka points out, from the reality of modern Japan. The elderly members of the congregation have a "pristine and idealized sense of being Japanese," recalling a country that no longer exists.

"The temple," she says, "is the nexus, with all these forces crossing one another." Still, she notes that a primary Buddhist principle is the constancy of change, so that even in the Enmanji temple, with its timeless connections to the past, life must go forward.

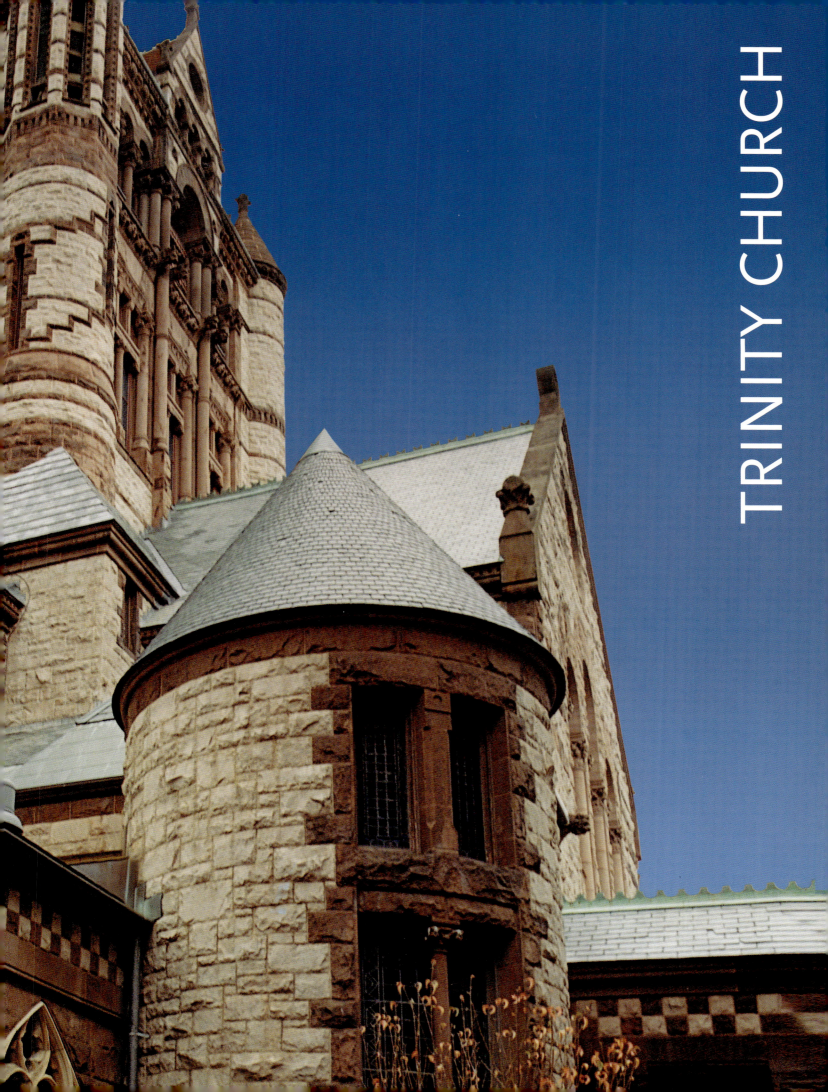

TRINITY CHURCH

In the middle of Boston, one of the most beautiful buildings in America, designed by H. H. Richardson after the Civil War, has just undergone a splendid restoration.

Very few places have a visual impact so enormous that it translates into a physical force. But a visitor entering Trinity Church in Boston, Massachusetts, is almost sure to be hit in the diaphragm, left breathless in the midst of unearthly earthly beauty. The interior, with a coffered ceiling and a soaring square tower, has walls of saturated Pompeiian red, decorated with superb murals of prophets, apostles, and angels, as well as biblical quotations. Light filters through stained-glass windows, including four by Edward Burne-Jones and William Morris, and John La Farge's astonishing three-part *Christ in Majesty*.

Consecrated in 1877, Trinity is a masterpiece, designed by the architect Henry Hobson Richardson and the artist John La Farge. Another powerful hand was also at work: Phillips Brooks, the dynamic Episcopal rector (and author of "O Little Town of Bethlehem") who had helped persuade the congregation of Boston's original Trinity Church that it needed a new home.

Richardson was only thirty-three when he won the competition to design the church in Copley Square. His plan—which he revised drastically, for structural and aesthetic reasons—was a dramatic departure from the austere Gothic style that dominated ecclesiastical architecture at the time. With it he established what came to be known as Richardsonian Romanesque, which grew from the medieval Romanesque style, with round arches, vaults, and ornaments, and sight lines unimpeded by columns. (Richardson, who died in his forties, is almost unknown to the general public today, but still revered by those in his profession. A 1991 poll of members of the American Institute of Architects ranked him one of the country's three all-time greatest architects.)

The inside of Trinity is a sharp contrast to the sandstone exterior. "A rich effect of color in the interior was an essential element of the design, and this could not be obtained in any practicable material without painting," Richardson wrote. "The use of granite was a necessity of construction, [but] the cold, harsh effect of this stone in the midst of the color decoration could not be tolerated." Thus, walls were plastered. Like Richardson, La Farge had studied in France and made his reputation with his work at Trinity, much of which was done in severe circumstances. The church was unheated, the budget was tiny, and the timetable worse, yet in about four months La Farge and his team (which included Augustus Saint-Gaudens and Francis David Millet) painted murals and colored geometric motifs that complement the architectural details.

Phillips Brooks was a legendary speaker, and Trinity was configured for preaching. Though the church seats 1,200, it is warm and embracing, in part because the footprint is relatively small. There are no side chapels, and the galleries hold several hundred people. Even in a full church, no one is far from the minister. Brooks preached from a table; the large pulpit that graces

ABOVE: *Charge to Solomon,* a magnificent stained-glass window by the English masters Edward Burne-Jones and William Morris, is in the baptistery.
OPPOSITE PAGE: The architect also designed the richly carved pews, which fill not only the sanctuary but two side galleries above it.
NEXT PAGE LEFT: Trinity is fortunate to have two Aeolian-Skinner organs. This newly restored one is in the back of the church.
NEXT PAGE RIGHT: *The Resurrection,* a stained-glass window, is by John La Farge. A pioneer in layering opalescent glass, he said, "Window decoration is the art of painting in air."
FOLLOWING PAGES: The chancel, which was redone in 1938, has a solid marble altar. The carved wood cross is decorated with gold leaf and polychrome.

Trinity now was added long after he died. (A visiting bishop is alleged to have said that "it sleeps eight.")

Trinity is a living organism with 4,000 congregants. "From the start, the emphasis was on preaching and teaching," says the vicar, Rev. Pamela Foster. "Forming Christians as disciples and sending them out is central. We seek not to give answers but to encourage people to question, even doubt, and talk with others. That's what builds a community."

In 2005, the church finished a $53 million renovation by Goody Clancy architects. "It was daunting from the beginning, and it took great courage," says Jean Carroon, a preservation architect at Goody Clancy. "It took courage to build this church, after the Civil War, and there are similarities between then and now: a commitment to the city, to a mission, to make design lift the spirit." With the colors revivified and the windows freed of decades of grime, the church is vibrant. "We found so many little details that had been lost or painted over," she says. "You really realized you were following behind genius."

Because there was no space for a sizable gathering, the architects also added a handsome undercroft, which is home to a variety of activities. "We saw an opportunity when we came into the basement and saw wood framing above and the incredible granite foundation," Carroon says. "Instead of covering up, it was about celebrating below ground. That was part of the magic. It was a collaborative process; there were involved committee people in church." Some of the church's foundation is visible and celebrated, incorporated into the design: cherrywood benches snake around four enormous rough granite supporting columns.

Those who work in Trinity delight in their surroundings. "To carry out the priesthood in this beauty is awesome in the true sense of the word," Reverend Foster says. "When I celebrate Communion, I am seeing *Christ in Majesty,* which is a tremendous sight line privilege." The words "Blessing and Honour and Glory" glow just above the chancel and the altar. "Lift Thine Eyes" would have been equally apposite, for art and architecture together draw the eye upward. And what a blessing that is.

I CAME THAT THEY MAY HAVE LIFE AND HAVE IT ABVNDANTLY ✠ HE THAT DOETH THE WILL OF GOD ABIDETH FOREVER ✠

CIVIC CENTER SYNAGOGUE

In downtown Manhattan, a modernist synagogue in nineteenth-century surroundings offers services for the Orthodox and arts programs for all.

Of the three prominent art museums in Manhattan with modernist architecture—the Guggenheim, the Whitney, and the Museum of Modern Art—Frank Lloyd Wright's spiraling Guggenheim is the most famous and the most strikingly sculptural. But if you are wandering around far downtown in the trendy neighborhood of TriBeCa, threading your way past the bistros and the million-dollar condo lofts, you may be stopped in your tracks by a smaller modernist building with a similarly arresting sculptural aura, its contoured facade swelling outward to form a canopy over a glass-walled entrance and then curving back and upward, like an inverted question mark. You might think it's a small art museum, and you will find art on display inside, but it's a synagogue. The Synagogue for the Arts, as it's now semiofficially known, is also and always has been the Civic Center Synagogue, and the two identities reflect both the accelerated history of the neighborhood during the past three decades and the way in which a house of worship can have a distinct religious profile and a distinct architectural profile and still find ways to blend in with its surroundings.

When the synagogue was built, in 1967, the nameless neighborhood was a declining industrial district of small manufacturing firms and increasingly empty warehouses and lofts. But in the 1980s, an iron law of New York history kicked in. Artists, musicians, actors, and writers, fleeing the rising rents of former bohemian enclaves like SoHo and Greenwich Village, moved in, followed by galleries and small theaters, followed by chic bars and restaurants, followed by chic people and real estate mayhem. Yet TriBeCa's narrow streets and unexpected little squares retain their somber charm.

The Civic Center Synagogue was born modestly in 1938 in a storefront location above a barbershop and cigar store. It was the inspiration of Jacob J. Rosenblum, a special assistant to New York County district attorney Thomas Dewey, and it was intended to provide services for Jews who worked as civil servants in the nearby city government offices. In the 1960s, the block that it was on was bought up for what is now the Federal Building, and the synagogue was given a plot of land on White Street. The board of directors sought out William Breger, an architect who had been a student of Walter Gropius at Harvard and who was at that time chairman of the department of architectural design at Pratt Institute, in Brooklyn.

Breger had never designed a religious building. He had designed houses, winning several awards. But he specialized in what became known as "milieu therapy," designing therapeutic environments like clinics and nursing homes. The synagogue commission seemed to him something of a sideline, but he was determined to make the building stand out in what at the time was a

PREVIOUS PAGES: The curved front of the building and the rest of William Breger's design are deliberately different from the synagogue's considerably older neighbors, but the building is also unobtrusive.
OPPOSITE PAGE: A skylight 40 feet above the Torah scrolls, the lectern, and the menorah creates an explosion of light when the sun moves across in the middle of the day.

rough-edged neighborhood by proclaiming itself through religious symbolism and the modernist principles of the Bauhaus. The curved, seemingly undulating surface, he says, was meant to be evocative of biblical images like the burning bush, as well as to distinguish it from the conclusively pointed spires appropriate to Christian architecture. Judaism, he says, oriented toward a Messiah yet to come, is a less definite, more incomplete faith.

Breger's design won a National Honor Award in 1968 from the American Institute of Architects, and the synagogue flourished as a refuge for civil servants. But in the 1970s, the manufacturers left, the neighborhood deteriorated, the city government sank into bankruptcy, and the number of Jewish civil servants declined. The synagogue fell on hard times. The garden that Breger had designed, with a fountain and sculptures, was vandalized and replaced by a concrete courtyard, though the abstract sculptures, including two by Alexander Lieberman, survived and are still there.

When the present rabbi, Jonathan Glass, arrived in 1989, the synagogue was, he says, "in the doldrums," but the surrounding neighborhood was suddenly thick with creative people. He decided to reach out to them with arts programs, along with programs designed to get the unaffiliated Jews among them involved. Despite some financial cliff-hanging, leaks in the roof, and the lingering effect of 9/11 on the whole downtown Manhattan area, his vision has been to a great extent realized. The synagogue still offers daily services attended by civil servants, politicians, lawyers, and judges from nearby government offices. There are classrooms for Hebrew school and a reception hall for special events. The services follow Orthodox principles, including the separation of men and women, but they are open to all, and the rabbi delivers what are less like sermons and more like instructive lectures for the diverse congregations the synagogue now attracts. There are also art exhibitions, a lecture series on art and religion, and, in the recent past, film programs, concerts, and theater productions.

It's in the architecture, though, that the diverse aspects of the synagogue symbolically converge. It unites modern art and religious aspiration. The building is a thin concrete shell with marble tiles on the contoured outer wall. Inside is a soaring space for the main sanctuary, with the apex a skylight that results in, Rabbi Glass says, "an explosion of light" when the sun comes through in the middle of the day. The skylight is 40 feet above the platform on which the Torah scrolls, lectern, and menorah form the focal point of the religious services.

The design hasn't escaped controversy. Critics of modernist architecture and its refusal to concede anything to urban context and texture haven't overlooked the fact that the Synagogue for the Arts has nothing in common with the surrounding nineteenth-century facades, but Breger still believes that a religious building must separate itself from and transcend its surroundings. It's also worth noting that you don't see the synagogue until you are in front of it. Unlike more obtrusive modernist office and apartment towers, it doesn't show off and overpower the surrounding structures. Instead, its recessed entrance and curving outer wall seem to draw the observer in. And it continues to draw in not only local worshippers and people in, or interested in, the arts, but a much larger congregation of architecture students and tourists from all over the world. It's a good place for leaps of faith and of imagination.

OPPOSITE PAGE: Services, though open to all, are Orthodox. Men and women occupy the same long pews, but they are on opposite sides of delicate curtains that divide the seating area.

FIRST CHURCH OF CHRIST, SCIENTIST

Almost a century after its completion, Bernard Maybeck's timeless masterpiece in Berkeley, California, continues to surprise.

Bernard Maybeck's First Church of Christ, Scientist, in Berkeley, California, is an American original, an elaborate ode to the great medieval cathedrals of Europe, wrought in the most commonplace of modern and ancient materials—concrete, wood, paint, steel, and glass. It was completed in 1911, and the near century that followed has not diminished it. The church is a triumph of imagination, artistry, and architectural expression.

Step inside. First there is amazement, then wordless wonderment. When the San Francisco architect William Marquand led tours through the church, he knew to wait until the impact of it all was taken in; he didn't start talking until first-time visitors had a moment to absorb the experience.

Great wooden trusses, rich with ornamental stencil work and inset with gilded Gothic tracery, cross the space below a stained-red ceiling. The paint on the trusses is just a few colors—gold, blue, green, red—but the effect is nonetheless dazzling. The trusses ought to suggest heaviness, but instead the whole intricate ceiling seems to rise, almost float, above the huge concrete columns that support the trusses. More gilded Gothic tracery screens the organ loft. Muted light—ever changing and colored only by the leaves, the clouds, the sun, and the sky—infuses the auditorium through the hammered glass of the windows. Brass lights hang from the ceiling.

Marquand, who did his Yale master's thesis on the church and served as the executive director of the San Francisco–based Maybeck Foundation, sees the auditorium as "a part of the tradition that, through its elaborate structure, space, and artwork, suggests the realms of heaven and earth."

It is quite a progression from the latter to the former. Outside, a simple wooden signboard welcomes all to Sunday services; otherwise, there are only hints—the Gothic imagery of the windows and subtle bas-reliefs in the portico—that this is not a sprawling Berkeley bungalow. The corner is cut away for an elaborate entry sequence—portico to pergola—in which you can head straight into what was originally the Sunday school or turn left and head toward the auditorium.

The facade is wood and concrete, with a tile cladding of cement asbestos, called Transite, which is ordinarily relegated to roofs and insulation. To achieve the right rugged patina in the concrete, Maybeck lined wooden molds with paper. The floors are concrete, the pews the same oak as the doors. Two lay readers—the church has no minister—stand behind a concrete desk elaborately painted in a fashion that intimates Japanese scrollwork. Maybeck had a rare combination of what Kenneth Cardwell calls "genius and perseverance." In 1940, Cardwell, then a student and now a professor emeritus of architecture at Berkeley, was out wandering the city's hilly streets, camera in hand, when

he encountered "an elderly man with a flowing white beard and intense blue eyes, dressed in baggy denim trousers and loose, peasantlike smock." That chance meeting led to a 17-year friendship, interrupted only by Cardwell's World War II service, until Maybeck's death in 1957. In fact, Maybeck—never a self-promoter—might have remained obscure were it not for Cardwell's 1977 biography of him.

Born in 1862 to German immigrants, Maybeck first followed his father into wood carving, but soon enrolled in the École des Beaux-Arts in Paris to study architecture. After a brief time in New York (with a firm for which he left his imprint on two quite astounding hotels in St. Augustine, Florida) and in Kansas City, he made his way to San Francisco in 1890.

The Berkeley Christian Science group had split off from a church in neighboring Oakland. By 1909, the plans committee—five women—of the Berkeley church approached the artistic, iconoclastic, ever inventive Maybeck, who by then had a prodigious architectural practice in the Bay Area. He said no. He told the committee that his building, one that would be the same on the inside and the outside and designed "without sham or hypocrisy," would not suit them. But the ladies of the plans committee selected him anyway.

"The plans committee, after consulting twelve architects, unanimously recommended architect and engineer Mr. Bernard Maybeck," a 1933 history of the church reports. The ladies told Maybeck that their choice was based on both deliberation and prayer, and he was persuaded. They gave Maybeck a list of the qualities they wanted in a church: unity, harmony, beauty, light, peace, sincerity.

Cardwell says that Maybeck always called First Church "modern," but it is a particular kind of modern. Maybeck is often quoted as having said he wanted to put himself "into the shoes of a twelfth-century man." Yet he was an architect of fertile imagination, restlessly curious, and his modern church incorporates elements of Craftsman, Gothic, Romanesque, Mediterranean, and Byzantine architecture.

"Maybeck was totally ageless," says Anthony Bruce, director of the Berkeley Architectural Heritage Association. "He never thought of himself as being in a particular time or place."

Over the years, the church's original metal roof was replaced by tile. In 1928, Maybeck and the Berkeley architect Henry Gutterson added a Sunday-school wing, which replaced what is now called more simply the Fireplace Room. The Maybeck Foundation is currently taking steps to keep the structure stable and ensure its survival. The present keepers of the church fastidiously maintain it and study it in minute detail, ever amazed that there is more to discover. They can point to places where scraps of paper from the board-form molds adhered to the concrete, where the architect inserted his signature mark (the initials of his wife, Annie Maybeck, in the shape of a stylized bell), and to the few isolated dabs of orange paint on the side of the reader's table. "Maybeck was always stretching your eye," Dickinson says.

Yet even those who know this church best—its keepers and the scholars who have studied it—still share the experience of first-time visitors. They step through the door, pause, and look up, taking it all in, gazing quietly with undiminished awe.

OPPOSITE PAGE: Maybeck gleaned details from the Gothic, but made them his own, incorporating them with other styles, including his own Craftsman architecture. The striated and carved pediment of the facade is original and timeless.
FOLLOWING PAGES: The church has kept to Maybeck's vision quite faithfully, including the Fireplace Room, with its painted wood-beamed ceiling and commodious hearth.

FIRST PRESBYTERIAN CHURCH

In Stamford, Connecticut, the massive gray whale-like facade of what is known as the Fish Church gives no indication of the glory within—a dramatic display of color and light.

There is no way to be prepared for the experience of entering this church. From the outside it is unpromising, even a bit forbidding, its faceted walls taking the wholly unexpected form of a giant whale.

But step inside and all uncertainty vanishes. Daylight and doubt give way to momentary darkness before the sanctuary unfolds: vast, soaring, and filled with jewellike light, as if a kaleidoscope had been turned inside out. "Everyone has the same reaction—a gasp and a quick intake of breath," says the Reverend Mary Marple Thies, one of the pastors who preside over this astounding space, the First Presbyterian Church of Stamford, Connecticut.

Its architect, Wallace K. Harrison, once said that he was hoping for "a shock of splendor" in the church. There is the intricate geometry of immense, folded concrete panels rising 60 feet to a peak, and the brilliant light cascading through 23,000 individual pieces of stained glass. It is dramatic and unexpected.

First Presbyterian resembles a huge fish, and for almost fifty years it has been known as the Fish Church—an epithet that somehow gives short shrift to the force of its architecture. When the church was dedicated in 1958, newspapers across the land—in Van Wert, Ohio, and Red Wing, Minnesota, not to mention Monessen, Pennsylvania, and Shawano, Wisconsin—wrote about it. "Sanctuary Like Gigantic Fish," one proclaimed; "Majestic Symbol of Faith," said another. Magazines reported on it, too. *Time* ("A Whale of a Church") and *Life* ("Holy Mackerel") were somewhat flippant, but *Look,* now long defunct, took it more seriously: "A Lofty, Luminous Church," it proclaimed, perhaps most accurately, for this is a building that looks and feels like no other and that has been largely ignored in the annals of modern architecture.

Harrison, who was born in 1895 in Worcester, Massachusetts, and died in 1981, was a self-made architect who designed some of the most prominent landmarks of his generation, including several buildings at Rockefeller Center, the Trylon and Perisphere at the 1939 New York World's Fair, and the United Nations headquarters. By the mid-1950s, when he began work on First Presbyterian, he had already received a full measure of fame.

Though he had spent considerable time abroad as a soldier and student, when he began work on the church he returned to Europe, looking at cathedrals on a quest for ideas. Ultimately, he went to Paris, and it was at the extraordinary Sainte-Chapelle—small and gemlike, with light streaming through exquisite stained glass—that he found "a precious, thrilling conflagration," as he told a journalist at the time.

His Stamford church is both medieval and modern, undeniably Gothic yet entirely original: long, tall, voluminous—a total of 220,000 cubic feet.

PREVIOUS PAGES: The church, with an austere but arresting exterior, made an enormous impact when it was dedicated in 1958.
OPPOSITE PAGE: The stunning sanctuary, with walls of stained-glass windows, is intended to surprise. Worship is sharply focused, as pastor and congregation strain to see one another in the voluminous space.

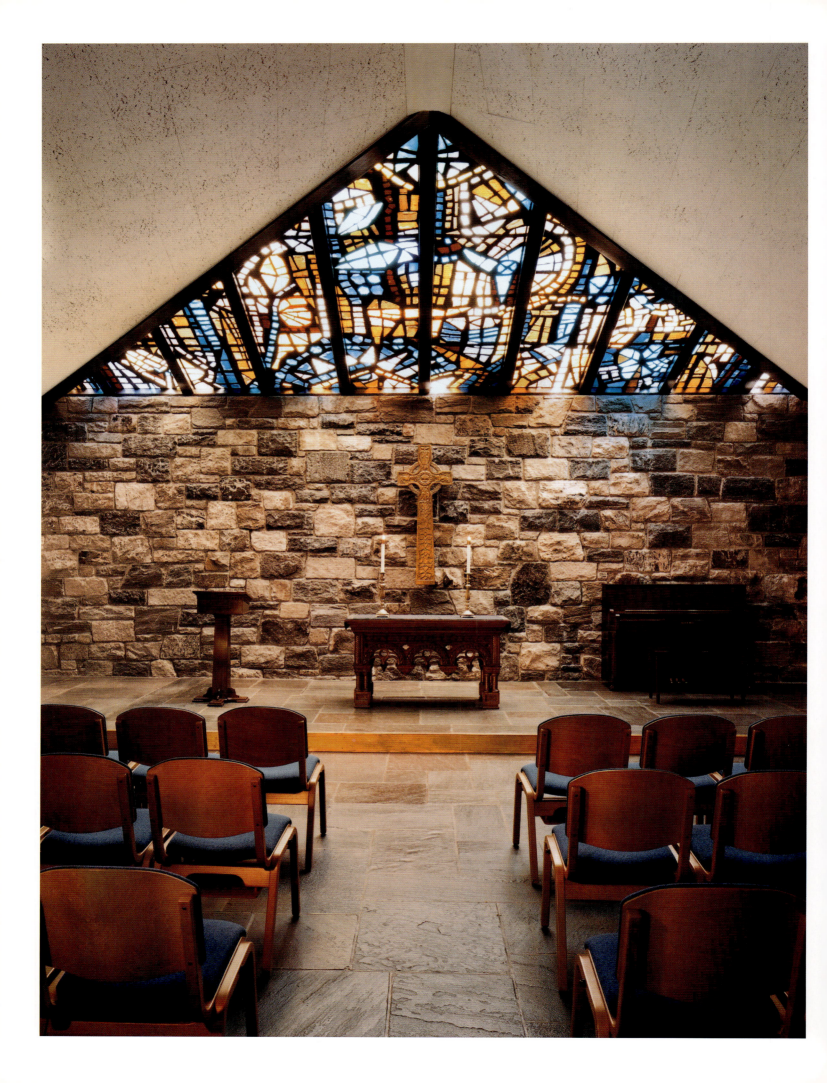

"Harrison was after mystery. He wanted nothing to distract," says the Reverend David Van Dyke, the other First Presbyterian pastor. "The feeling is more like a European cathedral, with that mysterious void where God hangs out."

From the pulpit, the ministers strain to see the parishioners in back, and vice versa. "It forces the congregation to be much more emotional about their commitment, because it focuses their attention," Thies says. "The space demands big music. It demands big gestures."

Working with little precedent, Harrison experimented in his backyard, in Long Island, to develop precast concrete panels creased like giant works of origami, erected at various angles. "That folding he did was really a forecast of today," says architectural historian Victoria Newhouse, his biographer. "It's really very effective."

For the stained glass, he turned to Gabriel Loire, who lived in Chartres and whom Harrison had found on the recommendation of the artist Fernand Léger. Loire designed the narthex window, but the rest of the windows were Harrison's. The glass was made in France and inserted into the concrete panels. Windows in two walls tell the story of the Crucifixion and Resurrection in thousands of pieces of glass, using abstract symbols as well as some figurative imagery. A few years ago, the south wall had to be removed and rebuilt with new glass set in epoxy, as the hot summer sun had wreaked havoc with the concrete expansion joints. A new organ was installed in 1991, but for the most part the church is much as it was at the beginning. "Because people had to take such risk to build it, they have a huge emotional commitment to it," Thies says.

One former pastor, George Stewart, was an army chaplain in World War II and in that position became a world-class ecclesiastical scavenger. Thus the cross in the chancel is made from wood from Canterbury Cathedral Library, which was bombed by the Nazis. A stone behind the pulpit is from Warburg Castle, where Martin Luther hid from 1521 to 1523 as he translated the Bible. A second cross placed in the church's separate chapel has nails from Coventry Cathedral and wood from the Pilgrim's Oak, a gift from the English town of Bury Saint Edmunds. Elsewhere, there is a long wall embedded with rocks that Stewart gathered around the world—Galilee, Jerusalem, Notre Dame, Delfshaven—each having a particular significance to Christians.

As for the fish shape, Newhouse points out that it was entirely unintended, a necessity of engineering rather than a purposeful symbol. But history is rewritten quickly, and by the time of the dedication in March 1958, the author of a commemorative booklet wrote that the sanctuary was "inspired by an ancient symbol of Christ still to be found in the catacombs. Christ fed the multitudes on loaves and fishes. He exhorted his disciples to be fishers of men. To early Christians, the Greek word for fish, *ichthys,* had a secret meaning. "

The speaker at the church's dedication was the renowned Eugene Carson Blake, a Presbyterian minister who had become president of the National Council of Churches and who was an early leading spokesman for civil rights and world peace. He saw the beauty and wonder that Harrison intended, saying of the church "storied in glass, enhanced by art": "I see and, more, I feel the ancient answer to the ancient question."

PREVIOUS PAGE LEFT:
The church's architect, Wallace K. Harrison, designed the concrete panels. Folded rather like origami, they are an engineering feat ahead of their time.

PREVIOUS PAGE RIGHT:
A concrete dove ascends between the double doors at the entrance to the church.

OPPOSITE PAGE: The jewel-like windows are constructed from thousands of pieces of inch-thick glass made in France and then set into the concrete panels.

CONGREGATION B'NAI YISRAEL

Architect Lee H. Skolnick's strikingly simple temple is at one with its site, a tree-filled slope in Armonk, New York.

The suburban landscape of Armonk, New York, is one of subtleties and incongruities. Low stone walls line the roads, standing sentinel in front of old and new alike. There, nestled tight into four wooded acres, is Congregation B'nai Yisrael. The temple does not announce itself, architecturally speaking, but rather unfolds gently as it comes into view—a wall first, then a glass pavilion under a curved roof that seems almost to float overhead. Indeed, so modest is its presence that even those who know to look for the building sometimes end up driving right by.

A synagogue has been in this spot for two decades, but until recently the congregation occupied a former Lutheran church with a design that some thought was more reminiscent of certain fast-food outlets than of a place of worship. New York City–based architect Lee H. Skolnick and his partner, Paul Alter, had the privilege of designing a new temple for this Reform Jewish congregation.

The temple sits in perfect concert with the land, a sloping site that runs from the comparative chaos of a busy suburban road to the tranquillity of a protected wetland. Skolnick saw in that terrain a perfect metaphor for the architecture. "I develop a narrative for every project," he says. "I create a set of themes and develop them so that I can weave together something that is cohesive."

The idea here is that of a journey, and it is a story told in architecture. An unadorned stucco wall begins the procession. It's an abstraction, Skolnick says, of Jerusalem's Western (Wailing) Wall, but it is also the central organizing element of the architecture. The wall leads worshippers into the synagogue and continues into the space through a small wood-clad vestibule, then into the lobby and on to the sanctuary and back out to the edge of the woodland beyond. "It's not only about the strict laws of Judaism—we want to keep people focused on whatever level of expression they bring to it," Skolnick says. "It's a simple idea, but it's poetic."

The path along the wall slopes down to the building, yet the wall continues at the same elevation, so it grows taller the closer it gets to the building. The effect is potent, a wordless way of implying the presence of a greater force. The act of arriving to worship is one that leads from the temporal to the spiritual. "The idea of the journey is really about your life on earth," Skolnick says, "about being responsible in a positive way for who you are and what you know. It's about making the most of your life, being good to people, being in love, being part of the community."

The sanctuary opens wide onto the wooded wetland that is B'nai Yisrael's backyard. There is no stained glass in this sanctuary. A profusion of maple, oak, and tulip trees rises high and stretches farther than the eye can see, into the landscape. The changing seasons offer all the color and plenty of evidence of God's handiwork. "In the autumn, yes, it's spectacular, but so is winter. And

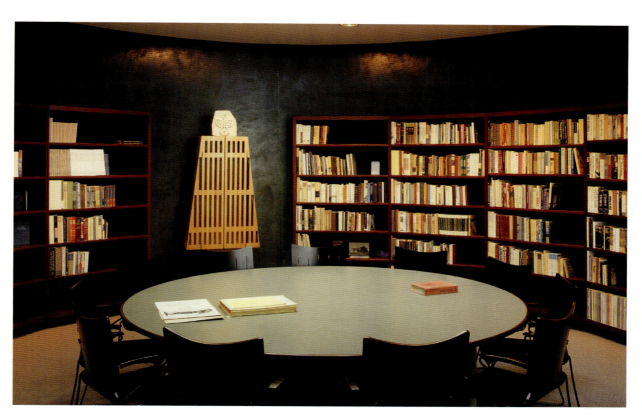

ABOVE: The synagogue's library has rounded walls to provide an elegant space for books and documents. A large, round reading table is used by rabbis, staff, and congregants.
OPPOSITE PAGE: The sanctuary faces the woods, allowing for an ever-shifting panorama as the seasons change.
FOLLOWING PAGES: As the property slopes downhill, the metal roof slopes heavenward.

in spring, it just explodes," Rabbi Douglas E. Krantz says. "It's glorious—that's also about the processional."

Krantz gave Skolnick few instructions at the onset, asking only for a space that felt intimate but would seat 250. The architect created an embracing space with perfect sight lines and wonderful acoustics. In his early years, Skolnick started out as a composer, then made the not-so-sharp turn into architecture (especially if one believes the adage that "architecture is frozen music"). He describes the shape of the sanctuary as "the inside of a mandolin. The sound resonates and is very warm."

Walls flare slightly, so they are not parallel. The bimah sits front and center. There are pews up front and, in the back of the sanctuary, chairs—an arrangement reminiscent of early American churches. A small mezzanine is reached by interior or exterior stairs. The ceiling is washed Douglas fir. Upholstery and carpeting are gray-green tweed. "I wanted it to be soft and neutral," Skolnick says.

"This whole room just works—the wall, all of it," Krantz says, "because it's so simple and well designed. It's just wood and carpeting and stucco and glass, basic elements." By day, the space is infused with sunlight. At night, the interior becomes almost magical. The lights in the ceiling gleam in the glass like stars twinkling in the sky. The woodland turns black, and the trees become almost skeletal, faint outlines, like a woodcut rather than a painting. "You feel at home, but you still are in awe at the beauty of it," Krantz says. "There's a power and a gentleness to it, but it's also a reflective space."

Shortly after B'nai Yisrael was finished, Skolnick's daughter, Elizabeth, celebrated her bat mitzvah there. "Having my daughter here reading from the Torah was just the quintessential moment," Skolnick says. "I really love this synagogue. To do an inspirational building is an architect's dream. And when it happens, it transcends all the other projects."

FLUSHING QUAKER MEETING HOUSE

Built in 1694, this Quaker meetinghouse in an ethnically diverse neighborhood in Queens, New York, remains a serene and welcoming space.

The Friends meetinghouse in Flushing sits just off the street—silent, sober, even stalwart amid the bustle and the grit of the city. It is not necessarily an imposing building. Quakers do not believe in creating elaborate monuments to God, and instead build modest structures that respect both mankind and nature. So this is a square, symmetrical house of worship, with well-weathered shingles and shutters. There is enormous power in its plainness and simplicity; its importance—and its beauty—are to be discovered in its elegant form and pure proportions.

When this meetinghouse was built, in 1694, Flushing was a countryside village inhabited by a few Dutch and English settlers. Today, as part of the New York borough of Queens, it is a dense urban melting pot of immigrants from Latin America, Korea, China, India, and almost every other imaginable country; a 2000 census identified more than forty languages regularly spoken in Flushing, including Urdu and Tagalog.

Step through the gate and walk around back to the entrance—early Quakers faced their meetinghouses south to capture the winter sun and the summer breeze—and you will step into another world, not just back in time. This meetinghouse is not only a repository of history, and important history at that, but a rare place of peace in a city that is seldom serene.

A notice on the door offers advice to new worshippers, and it is advice to be well taken: "Do not be anxious about distracting thoughts, but ride through them to the still centre, and try, if only for an instant, to let yourself be quiet in body, mind, and soul."

With an expanding congregation, the meetinghouse itself expanded in the early 1700s, and it now looks much as it did then. "We still even bar the doors in the same way," says Joan Kindler, an antiques dealer and an elder who also acts as the building's historian. Indeed, the meetinghouse was heated by woodstoves from 1760 until 1956; one stove remains as an artifact. The benches are comparatively new, replacements made in the early 1800s: during the Revolutionary War, English soldiers occupied the space and used the original benches as firewood.

Much else is as it always was. The floor is broad planks. Long, dark beams cross the plaster ceiling. In the rooms upstairs, used for classes and informal gatherings, you can see the 40-foot hand-hewn oak timbers used in the original construction and the gnarled, and utterly sculptural, "ship's knees" bracing—brackets carved from the roots and trunks of trees in the same technique used by boatbuilders of the era.

Today, with shops flanking it and apartment buildings towering over it, the meetinghouse seems ever more profound. There is a small graveyard with

PREVIOUS PAGES: The meetinghouse looks much as it did in colonial times. A developer offered a million dollars for air rights to its land, which has many old trees, but the Quakers wouldn't sell.

OPPOSITE PAGE: In the striking meeting room, with its floor of broad planks, some benches face each other to facilitate discussions.

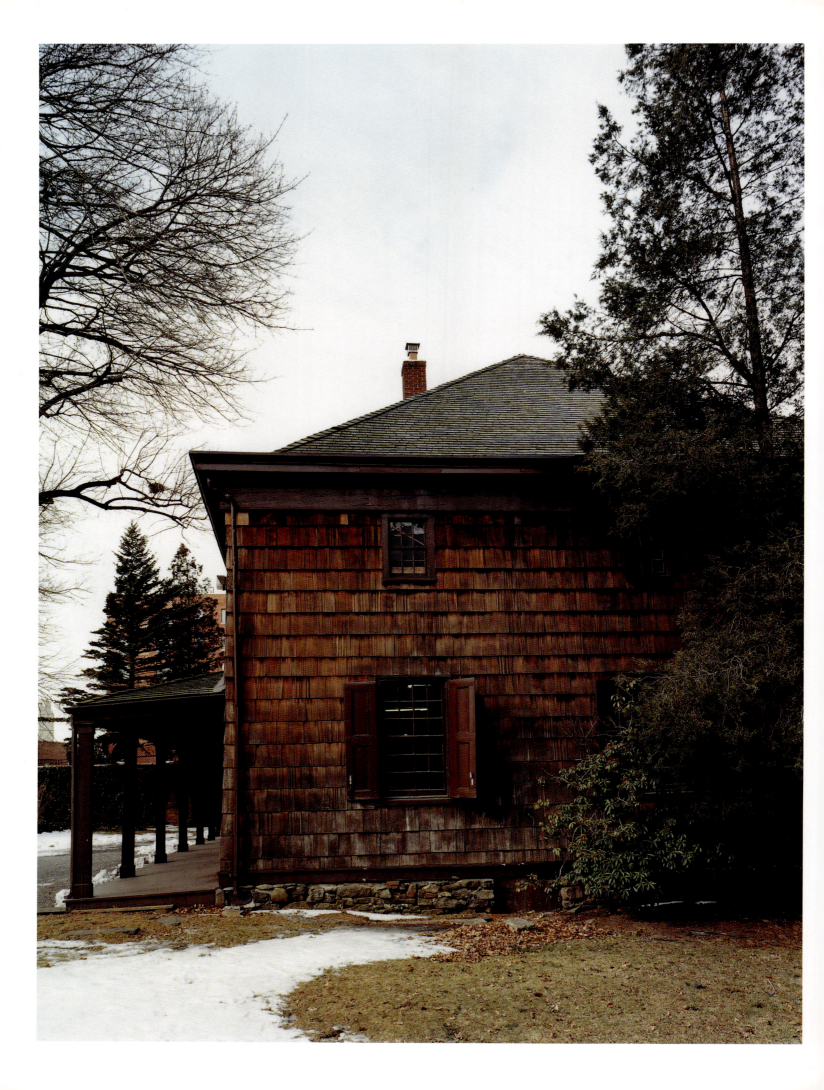

remarkable old trees—giant oaks, ashes, and wild black cherries among them. Not long ago, a developer offered the Flushing meetinghouse a million dollars for the air rights to its land, which would have allowed the adjacent apartment buildings to be even taller. "We refused," Kindler says. "We felt we were the proper stewards of the land and had to do right by it."

That concept of "right relationship" is a powerful one to Quakers, and it encompasses more than just daily life: it embraces the time-old question of how and where to build, the idea of architecture. George Fox, founder of the Religious Society of Friends, said, "Let your lives speak," and for Quakers this tenet is central. Now, as then, they grapple not just with the weighty questions of peace and war, but with the increasingly complex issue of treading lightly on this earth.

The Flushing meetinghouse is the second-oldest Quaker meetinghouse in continuous use in the United States; it is also thought to be the oldest house of worship in New York State. That alone might be significance enough, but Flushing's Quakers were also a crucial part of the establishment of religious freedom in America.

Though many of this country's first settlers came to the New World in search of religious freedom, they did not truly find it in the early colonies. New York under the rule of Holland allowed only one church, the Dutch Reformed Church, and persecuted others, most particularly Quakers. In 1657, a group of non-Quaker citizens of Flushing protested the imprisonment of a Quaker by writing a "Remonstrance" to Governor Peter Stuyvesant. "We therefore in this case not to judge least we be judged, neither to condemn least we be condemned," it read. But religious persecution continued, and in 1662, Stuyvesant's soldiers arrested and banished John Bowne, the leader of the Flushing Quakers. Bowne made his way to Amsterdam and pleaded his case to the directors of the Dutch West India Company, who in turn issued a decree of religious liberty. Bowne returned to Flushing, and for three decades the Quakers met in his house, now a National Historic Landmark. The meetinghouse, too, is a national landmark, and is also part of the Flushing Revolutionary Trail. But on Sundays, Quakers' First Day, it is just what it has been for three centuries: a meeting place.

In changing times and a changing place, only a handful of worshippers gathers here now, and some come from backgrounds much different from those of the early English settlers. They are drawn in by the sign out front that welcomes them in Korean, Chinese, and Spanish, and, like the first Quakers, they are making new lives in a new land. Ironically, in a seemingly ceaseless cycle of history, they are also seeking the freedoms that the founders of this meetinghouse sought and won—the freedoms to assemble and worship and speak. "It isn't just for Quakers," Kindler says. "It really is a symbol of religious freedom, and it has enormous significance in the city, the state, the country."

OPPOSITE PAGE:
The weathered, shingled meetinghouse with wooden shutters is a peaceful oasis on a busy city boulevard.

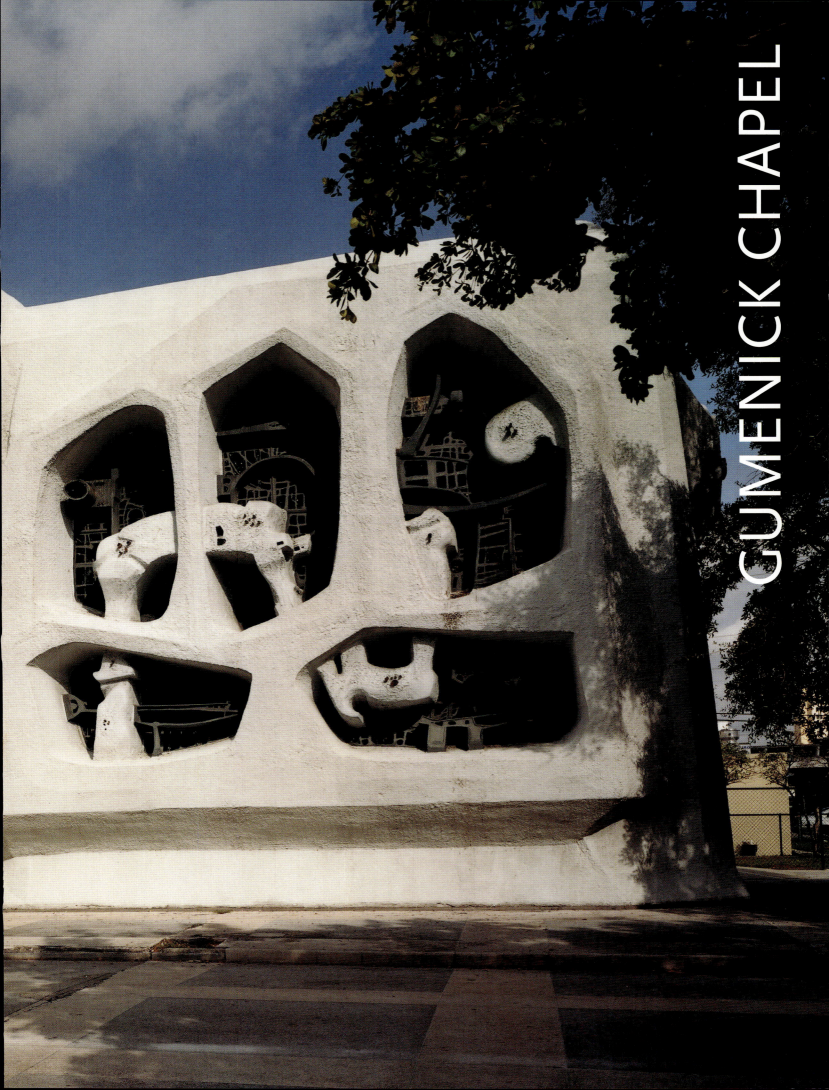

GUMENICK CHAPEL

Taking his cues directly from Genesis and Exodus, architect Kenneth Treister designed a Miami synagogue chapel that pulses with light.

More than three decades have passed since architect Kenneth Treister designed the Gumenick Chapel at the historic Temple Israel in Miami. It is organic and free-form in its design, an ode to abstraction in both its architecture and the art that is intrinsic to it. Treister wanted to create "a place where the human spirit would soar and the path to God would be made shorter."

The design is driven by ideas Treister derived from his reading of the Bible and his study of Jewish spiritual history, but it starts with the simplest of all mandates, from the first verses of Genesis: "In the beginning God created the heavens and the earth. The earth was without form and void, and darkness was upon the face of the deep.... And God said, 'Let there be Light'; and there was light."

Thus, clear natural sunlight beams down onto the Torah—"a shaft of light, God's light," Treister says—and a refracted rainbow of brilliant color bursts through the stained-glass windows to create an ever-changing pattern. Treister regards light, shade, and sun as "the brushes with which the architect paints," and indeed they offer symbolism and solace in a space that is free-flowing and sculptural. "It's very radical architecture," Treister says, "but it is traditional in terms of the meaning of the works of art."

Controversial from the start, the chapel remains so today. Over the course of its first years, the exterior got dark and splotchy after a misbegotten "renovation." Only recently was it brought back to the light coloration the architect intended. That it is bright once again is appropriate as a metaphor for the temple and its neighborhood. In the 1920s, when Temple Israel chose 19th Street, just north of downtown Miami, the neighborhood known as Miramar was affluent and alive; over the decades, it deteriorated into a place of a certain amount of desolation and despair. Today, both the neighborhood and the temple are in revival.

Temple Israel is the city's oldest Reform congregation and home to many of Miami's pioneer Jewish families. The historic building, which was designed in 1922 by the brilliant and unsung H. George Fink, is a Moorish-inspired work, an ironic choice, perhaps, given the course of history, but one that seems true to its place and its time.

Connected to the original building (the main sanctuary is still the primary worship space, in weekly use), the chapel is officially known as the Sophie and Nathan Gumenick Chapel, after the couple who endowed it. Like the original, this chapel is a work of its time, too, a compelling product of the 1960s. It speaks strongly to the restlessness and experimentation of the decades after World War II.

Reform Judaism is, as much as anything, a search for truths rather than a recitation of them. The architecture of this chapel is intended to echo that quest. From the beginning, Treister sought guidance from the Bible, where he found the passages in Exodus that specify the construction of a sanctuary, "the pattern of the tabernacle and all its furniture," he says, right down to the building of the ark to hold the covenant. Then, standing in front of Temple Israel, he looked at the site. "I used my hands to envision a space that would nestle a congregation," he says. "I rounded my hands, and there was the shape."

Treister is an avid and lifelong student of architectural history, with a universe of intellectual pursuits, but among them, Antonio Gaudí and Frank Lloyd Wright remain foremost. In this chapel, the affinity for Gaudí is apparent, the invocation of Wright more subtle. Ultimately, the design is so personal that some longtime Temple Israel staffers call it Mr. Treister's Chapel.

The building itself was created on site, without beams, columns, or formwork. "It is a large piece of sculpture," Treister says. The skeleton was made of metal that was twisted and then covered with Vinlox, a lightweight spray-on concrete in short use in the 1960s. "The form is true to itself, like the human body," Treister says.

Inside, the concrete walls fold inward, embracing the space. The architect followed biblical guidance, though interpreted. In Exodus, the wood is specified as acacia; the ark here is made of lignum vitae, a tree found in the Florida Keys that is similar to acacia. The ark holds the Torah, and it is of course in the bimah, the focal point of the sanctuary. Tradition holds that the bimah should be on an east-facing wall, looking toward Jerusalem, but Treister felt that would detract from the congregational experience he sought. He turned to the chapel Wright did at Florida Southern College in Lakeland, and put the bimah in the center of the long axis, "in the tradition of the prophets, who would stand under a tree and speak to their followers."

He gave the eastern wall a single stained-glass window, one that is especially brilliant in the morning as the sun shines through it. The lone window is so placed "because the central concept Judaism gave the world is that there is just one God," Treister says.

Early drawings for the chapel had been published, and at one point Treister received a letter from two artists, Benoit Gilsoul and Karel Dupre, who wrote that the sketches reminded them of a passage in Ezekiel in which a valley of dry bones is brought back to life by the breath of God. Their vision appealed to Treister, and together the three created the windows out of epoxy and 2,200 pieces of glass cast at Val St. Lambert, in Belgium. That the windows are predominantly blue, purple, and red is also part of the prescription laid out in Exodus.

By day, the chapel's interior is infused with colored light. At night, it is much the opposite: it is the outside that becomes luminous. For the architect, this is the "rhythm of nature, manifested by its changing light." Dark to light, convex to concave. "Nature has its own rhythm," Treister says. "And I have always believed that nature, God, and religion are all one."

PREVIOUS PAGE LEFT: Sunlight pours onto the Torah. The ark is made not of acacia, as it is in the Bible, but of a similar wood, lignum vitae, which is found in the nearby Florida Keys.

PREVIOUS PAGE RIGHT: In the foyer, light comes through hexagonal panes of glass that form the centers of Stars of David.

OPPOSITE PAGE: The chapel architecture is an ode to the work of Antonio Gaudí as seen through the eyes of now-retired Miami architect Kenneth Treister. For the stained-glass windows he selected biblical passages from the book of Ezekiel and rendered them in abstract form.

WHITNEY

DIAMOND A RANCH

HYDE HALL

BELCOURT CASTLE

In America, private chapels are often found in remote places. Understated or elaborate, they are built to serve individual needs.

Personal chapels, though rare in the United States, have proved enduring and indispensable to those who construct them on their usually rural farms and estates, where they have often been maintained with great care.

On Sundays, Marylou Whitney gathers her friends, guests, relatives, and staff for a short walk to church. As they walk, they sing, most often the old-fashioned hymn that begins "There is a church in the valley by the wildwood." The processional takes place at the Whitney Farm in Lexington, Kentucky, where the family chapel is fashioned from an old log cabin. When the Whitneys are in the Adirondacks, they worship in a venerable little chapel made of twigs, once a teahouse. In Saratoga Springs, New York, the family's personal chapel at Cady Hill House is new, but imbued with a powerful sense of history.

When Mrs. Whitney set out to build the chapel in Saratoga for her late husband, Cornelius Vanderbilt Whitney, she wanted to buy a small 1818 house that she loved and move it. Preservation laws forbade that, so she and her contractor measured, photographed, and documented the house to rebuild it as a place of worship. The resulting chapel has a bell from an old barn, and benches from a Quaker meetinghouse that was about to be torn down. A remarkable statue of Jesus, placed on the altar, became the chapel's focal point; it and other artifacts came from an archaeological dig in Peru and are thought to date to the days of the conquistadores Francisco Pizarro and Hernando de Soto. "The light comes right down and shines on that statue of Christ," Whitney says. "It just gives you goose bumps." The chapel is simple, purposely so. "It's airy and wonderful," she says. "I just go there to be alone and pray sometimes."

Throughout history, kings and czars and popes had chapels of their own. We know and admire many of these today—among them, Sainte-Chapelle in Paris, built by Louis IX, and Rome's Sistine Chapel, built between 1471 and 1484. Windsor Castle has Saint George's and a second small chapel rebuilt with windows designed by the duke of Edinburgh that commemorate the devastating fire of 1992. Britain's great houses and palaces often had a private chapel attached—in part, architectural historian Richard John says, because many families secretly remained Catholic after Henry VIII converted the country to Anglicanism. For other reasons, also often political, the palaces of the czars had personal chapels: the seventeenth-century Terem Palace, tucked behind the Kremlin, has two (one for czars, one for czarinas).

In the New World, however, in a land rife with Congregationalists, Presbyterians, and Baptists, the act of worship was inextricably free and as public as the act of government. Think of any New England town and in the

mind's eye the steepled church—solemn, wooden, white—is most prominent of all. Personal chapels were not the way of the land; they were (and still are) often built in remote places—the lakes of Wisconsin or Minnesota, the woods of the Adirondacks, the islands of Maine—because the nearest church was inaccessible.

Sometimes, personal chapels are born of necessity. "On a farm, life goes on, even on a Sunday," Whitney says. "We couldn't have a Sabbath. We needed a place where we could worship. Horses don't know that Sunday is a day of rest." In Kentucky, the Whitneys bought an ancient, rustic cabin said to have been in Daniel Boone's wife's family. They moved it to their horse farm, log by log, transforming it into a chapel that is "terribly primitive but somehow just magical." Cornelius Vanderbilt Whitney used to lead the services; now Mrs. Whitney's present husband, John Hendrickson, does the honors.

At Hyde Hall, the historic house near Cooperstown, New York, the Clarke family created a chapel from a lady's suite in the 1890s, removing a partition and lifting the ceiling to make it more cathedral-like. It remained a chapel until the 1920s, when it was converted to bedrooms; in 1994, a gift from Alice Busch Gronewaldt allowed for its restoration, and today it is a contemplative space used for small weddings, christenings, and memorial services.

In the 1960s, on a New Mexico ranch, Herbert Bayer designed a modernist chapel for the wedding of the owners' daughter. Composed of five arcs and paired with an old Mexican mission bell tower, it is a gem that is only enhanced by the contrast to the traditional architecture nearby. The current owners of the Diamond A Ranch, Gerald J. and Kelli Ford, don't use the chapel, but they do maintain it.

The desire to worship differently or alone has fueled the construction of a number of personal chapels, many of which are documented in Laura Chester's recent book, *Holy Personal*. As she wrote it, she built a personal place of worship, Little Rose Chapel, on the grounds of her home in western Massachusetts.

Personal chapels were commonplace at the plantation houses of the Louisiana bayou and Natchez Trace. Few remain today, and even fewer are kept up. The 1839 chapel at Laurel Hill Plantation near Natchez is open for public visits twice a year. Inside the stucco-on-brick building, with its Gothic spire, an alabaster font sits on a marble floor; the chancel is wood with a brick burial vault below. There was a minister briefly, but a 1948 history of Laurel Hill by its owner, Pierce Butler, noted that since 1850 the chapel had been used only occasionally: "Its statues and memorials are still there, and it stands, facing an all-devouring time, alone with its memories."

When O. J. and Jeannette Daigle bought Tezcuco Plantation in Darrow, Louisiana, there was no chapel. Mr. Daigle decided to build one when he and his wife set out to restore the main house in the early 1980s. As adjutant general of Louisiana, he had been responsible for the restoration of a number of buildings, and so had sources for old cypress and historic moldings. Thus the floors came from an old convent in New Orleans; the statuary, from a former monastery in Covington. The

OPPOSITE PAGE: The modernist concrete chapel at the Diamond A Ranch, designed in the 1960s by architect Herbert Bayer, has a bell tower that was recovered from a razed Mexican mission.

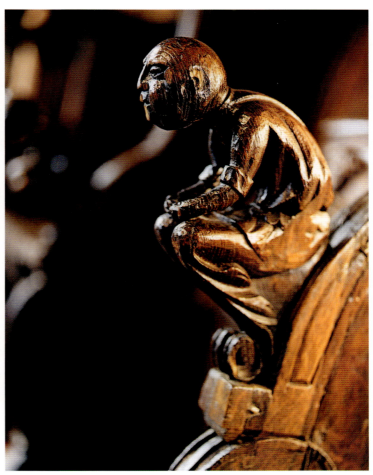

PREVIOUS PAGE LEFT:
Though the chapel at Belcourt Castle looks as if it has always been there, it was added by the Tinney family in 1979. The stained-glass windows survived World War II in Munich.
PREVIOUS PAGE RIGHT:
The simple interior of the Whitney family chapel includes wooden benches from an old Quaker meetinghouse.
ABOVE LEFT: The gleaming altar set in the Belcourt Castle chapel comes from a cathedral in St. Petersburg.
ABOVE RIGHT: Among the ecclesiastical riches in Belcourt's chapel is an Elizabethan oak choir stall, ca. 1600, with mercy seats. This is a captivating carved detail.
OPPOSITE PAGE: Oliver Hazard Perry Belmont built his stone summer house, Belcourt Castle, in the 1890s.
FOLLOWING PAGES: The Diamond A Ranch's dramatic chapel is especially surprising given its location, on a Southwestern spread whose other buildings date from the 1800s in fact or in style.

late Frank Hayden, a black artist from Baton Rouge, carved the cross; another woodworker, Hugh Ambeau, made a cornice.

Nor did the Newport house built by Oliver Hazard Perry Belmont between 1891 and 1894 have a chapel. Belmont favored his horses and built his house to accommodate 30 of them. Long after his death, the Tinney family bought the house, Belcourt Castle, just before it was to be demolished. They restored it and filled it with antiques, many from some 30 now lost Newport houses. In 1979, Harle and Donald H. Tinney created a chapel just off the banquet hall. On Sundays, the family pauses for a prayer or a brief service, but the chapel is also used for weddings and other small private services.

It is a room built of fervor, full of ecclesiastical treasures and antiques. The vestment chest dates from the tenth century, though it was altered. The rug is Chinese. The icons and the altar set came from Saint Isaac's Cathedral in St. Petersburg. Islamic prayer rugs hang on the walls. "When people ask what religion we are," Harle Tinney said in 2002, "the only answer we can come up with is ecumenical, though we had a Roman Catholic priest who came every Sunday. It was the only Roman Catholic Mass with Methodist hymns being played, because I was the organist, and that's all I know."

ALL SAINTS'

SAINT JAMES'S

Along the coast of Maine, a string of tiny, unassuming, yet beautiful handmade chapels—open only in summer—provides a sense of community and history.

The summer visitors to Orr's Island had been holding church services in the dining room of Bellevue Cottage for two years or so when the Right Reverend Henry A. Neely, bishop of Maine, wrote to them. He "heartily and gratefully" approved the movement to build a simple church there, he said, adding that "such a provision would be for the spiritual advantage not only of summer visitors but also of permanent residents."

And so the tiny All Saints' Chapel was born. It took eight years to build the shingled church, long enough so that when the worshippers outgrew the cottage dining room, they had to move Sunday services to the slightly bigger Moulton's ice cream parlor. A century later, All Saints' still calls to the Episcopal faithful of tiny Orr's Island. Every Sunday from June to September, the bright red wooden door opens, the cast-iron church bell tolls, and then the organ music—Bach, Handel, Vivaldi—begins.

All Saints' is one of eighteen such Episcopal summer chapels, historic and beautiful relics of an era when even slow-to-change Maine was a much different place. They are built of native stone, local hardwoods, or shingles, each structure somehow more astounding, more exquisite than the last.

The chapels have been so much a part of the summer landscape for so long that, despite their extraordinary architecture, they are easy to overlook. Unsung architectural jewels, small and discreet, they dot the coastline from York Harbor to Sorrento. Built by hand and nurtured by generations, they are also extraordinary social documents, protectors of faith and of tradition.

Another All Saints, this one called All Saints by-the-Sea, was built in 1905 on Southport, a quiet island just south of the more popular Boothbay Harbor. All Saints by-the-Sea rises almost organically out of the huge granite boulders at the water's edge. The parking lot holds only ten cars, and the chapel is not even visible from the narrow road that winds through woods and pastures. The chapel is reached by a footpath, but some worshippers arrive, as they have forever, by boat. In coastal Maine, the sea is the constant.

Winslow Homer, whose work gave greater glory to that Maine seacoast than any other artist's, painted watercolors of Saint James's Church in the enclave of Prouts Neck. "A church is being built with much hammering as it must be finished by July 1," Homer wrote to his sister-in-law Mattie in 1885. "It is very pretty—it is quite near my house." Saint James's is a modest shingled chapel that has an unexpected and extraordinary interior of wooden shakes shaped to look like fish scales. Though the list of past parishioners includes such families as Rockefeller and Merrick, the church is dedicated to "all them that go down to the sea in ships." It is—with the exception of the gilded pipes of the 105-year-old organ—a study in unassuming simplicity.

Only one of the chapels is well known: the oft-photographed Saint Ann's, which sits on a craggy point in Kennebunkport. Made of local stone, its architecture Norman-inspired, the chapel seems almost one with the landscape, as if that particular spot had been foreordained. Saint Ann's has remarkable Tiffany windows with nautical themes; shells are incorporated into the luminous pastel leaded glass. The chapel's renown, however, comes from more than aesthetics: Saint Ann's is the summer worship place of former president George H. W. Bush, and its organ is dedicated to Dorothy Walker Bush.

Trinity Church in York Harbor also boasts a Tiffany window high above the chancel. With seating for at least 350, Trinity is more capacious than most of the chapels, but when it was built, in 1908, York Harbor had a burgeoning summer population, with rather vast inns to accommodate tourists. Trinity was designed by architect Henry J. Hardenbergh, whose other works include the Plaza Hotel and the Dakota in New York.

Most of the chapels, though, are the work of no less talented architects whose names have faded into obscurity, such as the designer of All Saints by-the-Sea, Albert Hall. Others had no architect at all. Boat carpenters worked on the chapels, and the sanctuaries tend to resemble upside-down ships, "like Noah's ark," says the Right Reverend Edward Jones, the retired bishop of Indianapolis who for many years officiated at St. Peter's-by-the-Sea in Cape Neddick in August. "The Latin root for 'ship' is *navis,* but it also gives us the word 'nave,' or sanctuary."

St. Peter's was built in 1898 of local stone. Rugged and hand-hewn, yet almost Baroque, it is positioned high on a cliff and etched against the sky, creating an extraordinary silhouette. Inside, it is equally dramatic, board-and-batten with spectacular rafters crossing the vaulted sanctuary. The interior is taut and exuberant, consoling and embracing. Its architect, Charles M. Burns of Philadelphia, was important enough in his time and now largely forgotten, yet this chapel stands in testimony to his talent.

Cape Neddick was once a stop on the electric trolley that ran from the shipbuilding town of Kittery to the textile-manufacturing town of Biddeford. The little train stopped right at Christian Hill, where outdoor services had long been held. At the end of the nineteenth century, Philadelphian Nannie Dunlop Connaroe endowed the church that rose there. On summer Sundays, St. Peter's does not necessarily fill up, though nearby Ogunquit overflows with tourists. Bishop Jones muses that the changing vacation patterns of Americans, not to mention changing worship patterns, may endanger little chapels like this one. And, he points out, St. Peter's-by-the-Sea has no air-conditioning, no heat, and no plumbing. "Once," he says, "we'd glory in flinging the windows open to worship, but no more. We're far more pampered now."

Yet those who gather at Maine's summer chapels sit, as their forebears did, in straight-backed wooden chairs or pews to hear the old teachings. They are exhorted to make a list of old-fashioned vices to shun and virtues to embrace, and urged to stay rooted. Indeed, a summer chapel on Sunday is often a gathering of those who have kept the faith for generations. On Orr's Island, the stalwarts include Suzanne Baker, the organist, secretary, and historian, and her husband, Stanley, who is All Saints' Chapel chairman. (The Bakers are the third generation of their respective families on Orr's Island, and a summer Sunday can lure their daughter, Kim, who lives in Massachusetts.) At Saint Martin's in-the-Field one can find church committee member Penny Marshall, whose late husband's family had come to Biddeford Pool for a century. Marshall has been worshipping at Saint Martin's since she came to town as a bride in 1953.

Saint Martin's looks out over its own memorial garden and the rolling fairways of the Abenakee Club's golf course. When Saint Martin's in-the-Field was built, there was an agreement that there would be no play on Sundays or during a Saturday afternoon wedding, lest a golf ball be deflected in mid-flight. The rule barring golf during normal church hours still holds. "We do park in the middle of the second fairway," Marshall says.

James Rose is a Washingtonian whose family has long roots in Prouts Neck and at the chapel named for the patron saint of fishermen, Saint James. "Our children play with children of people we played with; their grandparents played with our grandparents," he says. "It's like the salmon coming back."

CHRIST CHURCH CRANBROOK

The forces of art and science, of the sacred and the secular, meet in this astonishing 1928 church in Bloomfield Hills, Michigan.

On the Sunday after the World Trade Center fell, the carillon at Christ Church Cranbrook summoned worshippers with the stirring call of the hymn "God of Grace and God of Glory." Across the rolling wooded landscape of Bloomfield Hills, Michigan, the bells pealed loud, offering consolation and inspiration.

Later, the congregation sang the hymn, which contains the refrain "Grant us wisdom. Grant us courage for the facing of these days, for the facing of these days." It was a profound and affecting moment. "I was playing the organ, but even so, I was very moved, especially when they sang those words," says Charles W. Raines, who was the longtime organist and music director at the Episcopal church and a student of its history. "As angry and scared as we were as a nation, we were also people of faith."

In both architecture and art, Christ Church Cranbrook pays powerful tribute to ideas and ideals — to tolerance, generosity, loyalty, service, and liberty. The church was conceived as an ode to beauty, to industry, to art and craft, and, even more, to the principles and philosophy of its founders, George Gough Booth and his wife, Ellen Warren Scripps Booth.

Yet it is also a church with deep roots in the faith of its founders and the faith of their forefathers. The Booths — he then an ambitious young Canadian new to Detroit, she a daughter of one of the city's prominent families — met at church and married in 1887. They became connoisseurs, collectors, educators, endowers, patrons, and philanthropists, and these roles all come to bear at Christ Church. "The Booths were artistic, intellectual, and liberal," Raines says. "They built a church to reflect their broad-minded leanings."

The couple were in the process of founding their now legendary Cranbrook complex when they built Christ Church, which was completed in 1928. Eventually, Cranbrook would include private elementary and secondary schools, a museum, a science institute, and an academy of art. Eliel Saarinen was the architect for many of the complex's extraordinary buildings, beginning in 1925, and originally led the design school. Cranbook graduates include such important mid-twentieth-century figures as Charles and Ray Eames, Harry Bertoia, and Florence Knoll Bassett. But first came the church. "The Booths' minds might have been on the schools, but their hearts were in the church," says Mark Coir, Cranbrook's chief archivist. Indeed, the stonework, wood carvings, stained-glass windows, tile mosaics, tapestries, and ironwork are testimony to the great passions of their lives, and an expression of almost all they believed in.

Walk into the church and you walk under words from the Bible that became a cornerstone of democracy: "Ye shall know the truth, and the truth shall make you free." Symbols of the world's religions — a Star of David, a Buddhist

PREVIOUS PAGES: The English Gothic church was completed just before the Depression and is a testament to the religious, intellectual, and aesthetic interests of its founders.
OPPOSITE PAGE: Almost as large as a cathedral, the church is never forbidding and seems almost intimate, in part because of its narrowness.

170

ABOVE: The award-winning Siena marble baptismal font has carved figures by Leo Friedlander. The cloisonné cover depicts races from four continents—each amid flora and fauna of the area—as well as the four evangelists.
OPPOSITE PAGE: The baptistery ceiling is of local Pewabic tile. The stained-glass window on the left depicts John the Baptist baptizing Jesus.
FOLLOWING PAGES: Around the altar, frescoes by Katherine McEwen depict the role and influence of the church in ancient and modern times.

prayer wheel, a Muslim star and crescent, a Chinese yin and yang—are carved into the tympanum above the entrance.

Step through the heavy oak doors into the narthex and there are two richly complex tapestries from the looms of England's Merton Abbey depicting the Rule of Law and the Rule of Love. Christ Church springs from religious fervor, personal devotion, and a passion for the arts. Study it and you will find wit, humor, and even social commentary. The Booths were involved in and fully embraced the principles of the Arts and Crafts movement, most notably the belief in the power of beautiful handmade objects to move us to higher aspirations. They exacted even more here, wanting the church to impart the social and philosophical message that art, science, and the search for knowledge were not merely secular pursuits. The church "speaks to the Arts and Crafts movement in America, in all that it meant," Coir says, "the spiritual direction, the social direction, the notion of the city beautiful, and more."

173

The western stained-glass window is the Women's Window, and includes likenesses in brilliant leaded glass of the sainted and the secular—scientists, artists, writers, actresses, educators, missionaries, nurses, and suffragists. Likewise, carved in stone along the building's facade are the Dawn Men, who range from religious reformers to explorers, from scientists to political leaders.

The English Gothic church is almost cathedral-sized, with a carillon tower rising high and a soaring sanctuary, long and thin. "In its loftiness there's that transcendent feeling, because of the height and length, but it's also narrow enough that there's an embrace," Raines says. The architect was Oscar H. Murray of New York, who inherited the job when his far more famous partner, Bertram Goodhue, died in 1924. The Booths chose English Gothic architecture as an homage to their forebears, but that was just the beginning.

Booth, the grandson of a coppersmith, began his career in the metalwork industry (and became publisher of the *Detroit Evening News* and owner of a chain of smaller Michigan newspapers), and he never left his love of craft far behind. Christ Church, says Robert Saarnio, the former curator of collections at Cranbrook, "is a total efflorescence of the Arts and Crafts movement in America. Really, it is the last time in history that all of this comes together."

Christ Church is a showcase for the glorious iridescent Pewabic tile, made in Detroit, that was used in the vaulted ceiling mosaic over the baptistery and on the floor of the chancel. One floor tile depicts a little horned imp, a wittily drawn devil; it is right on the path to the Communion table, so that all will tromp on the devil on the way to redemption. English silversmith Arthur Neville Kirk made the candlesticks and Frank Koralewsky the Communion service, which sit on the altar; American painter Katherine McEwen spent three years creating an elaborate fresco for the chancel walls. Artisans from Oberammergau, Germany, made the wood carvings—among them a series of vignettes about life and work and leisure in the 1920s—tucked away on the seats of the choir. During the church's construction, Booth learned that Merton Abbey looms, founded by William Morris, were closing, and immediately commissioned three tapestries, including the two that hang in the church narthex.

Less than a century later, in the face of impending war, the messages the Booths sought to impart in their church took on renewed meaning. The congregation filed into the church, past those two tapestries telling them of the Rule of Law and the Rule of Love, to listen to words of comfort and conviction, and to lift their voices together to ask for the wisdom and courage to go forth.

OPPOSITE PAGE: A winged horse is one of many creatures rendered in the mosaic tile floors throughout the church. This one is in the small St. Paul's Chapel.

A struggling area in Miami gets a true community church, thanks to architect Elizabeth Plater-Zyberk and an indefatigable local priest who reached out to local artists.

Tucked among the bungalows and bodegas of a dusty, run-down Miami neighborhood, the San Juan Bautista Mission seems somehow to have always been there. Step inside this tiny church and you are transported to another time and place. It is simple, yet fully embellished with art and antiques. An eighty-year-old lantern shines down on an elegant Pompeiian-inspired mosaic in the foyer floor. A bronze copy of a Renaissance sculpture of John the Baptist stands sentinel over a marble baptismal font.

Yet the church, designed by architect Elizabeth Plater-Zyberk (whose firm, Duany Plater-Zyberk & Co., did the work for free), was built only ten years ago, on what had been a debris-strewn vacant lot. Father José Luis Menendez had dreamed of building a mission church, and when he saw the site, he knew instinctively that it was the heart of the community.

Father Menendez was born in Cuba but reared in Spain, where he acquired his abiding passion for history, art, and architecture. To furnish the church, he haunted antique shops, persuaded artists to design mosaics and murals, and got donations of carved wooden pew tops and bronze and marble stations of the cross from a convent that was closing its doors. "I am in the recycling business," he says rather simply. But, in fact, he is in the business of adding luster to the lives of people who have little. "When you build something beautiful, even in the inner city, you convince people that they are important."

San Juan Bautista has an elegant yet unassuming presence on the street. Its flat, stucco facade, with a roofline rising to a single squared-off parapet with a bell tower behind it, conjures images of the mission churches of the Spanish Caribbean. Plater-Zyberk wanted the church to offer parishioners a feeling of belonging. She sought "to make ties, make connections, to emulate places of memory."

The church is articulated subtly, by shades of paint—cream and light green. To the left of the vestibule is a tiny chapel where the lights are always on, so passersby can peer through the window and see an exquisite nineteenth-century wood and polychrome statue of Mary.

The procession through the church is one from sin to salvation. "First you renounce, then you affirm," Father Menendez says. You step across the mosaic of a serpent, the age-old emblem of sin, to the open courtyard, with its baptismal fountain. Twelve columns, for the twelve apostles, flank the arcaded courtyard. Beyond that is the sanctuary, where light filters gently through glass-block clerestories and four very different stained-glass windows: two from nineteenth-century churches, a 1920s Art Deco window, and a contemporary design commissioned for the mission.

PREVIOUS PAGES: After Mass, parishioners and passersby can buy savories outside the stucco church.
OPPOSITE PAGE: A local artist painted the blue ceiling, a representation of the ascension of Mary. The faces of twenty-five angels surrounding her are not of imaginary cherubs but of children in the area.

180

Most dramatic, though, is the sky-blue ceiling with clouds floating across it: a local artist painted the ascension of Mary here and filled it with a flock of twenty-five angels, the likenesses of local children. "We have to use symbols like they made them in the Middle Ages," Father Menendez says. "Some people don't read and write. Some speak only English. Some speak only Spanish." The community around San Juan Bautista is not bound together by a common culture or even by a tradition. It is predominantly Puerto Rican, but also Honduran, Dominican, Colombian, Cuban, and American.

Not long ago, this neighborhood—sandwiched between Miami's garment and design districts and walled off by railroad tracks and the ramps and roadways of I-95—was best known for its bleakness. Today, little folk gardens bloom in front of freshly painted houses; artists and designers are transforming abandoned warehouses into studios and galleries. Next door to San Juan Bautista, where the primary activity was once gambling, now sits Mona y Angel, a tiny restaurant where diners eat at vinyl-covered picnic tables and the specials are *carne con papa* and *modongo*. The celestial meets the mundane here, and the message is clear: where there's faith, anything is possible.

On Sundays, the nineteenth-century bronze church bell calls parishioners to morning Mass. Young and old arrive, dressed in jeans and guayaberas, three-piece suits, and linen dresses. There is a low chatter as the musicians tune up. Then, at precisely 11 A.M., the bongo player hits the first beat. The guitars, tambourine, and accordion join in. The door to the sanctuary opens for the priest and the altar boy. The congregation stands to sing "Con Alegria y Júbilo," and another Mass at San Juan Bautista is under way.

ABOVE: A musician plays in the courtyard, where a statue of St. John the Baptist stands at the edge of a baptismal font. OPPOSITE PAGE: A tiny chapel with a magnificent wood and polychrome nineteenth-century statue of Mary is lit at all times so it is always visible to people walking by.

SAINT LAWRENCE

A Roman Catholic university chapel in Lawrence, Kansas, is a magnificent paradox—
sublime yet earthly, simple yet complex.

The architecture of Saint Lawrence Catholic Campus Center at the University of Kansas speaks of the infinite and of possibility. Yet this is a chapel with a profound sense of place, with architecture that celebrates the wide-open expanses of wheat fields and the unbounded prairie landscape. It is steeped in ecclesiastical architectural traditions, yet it is also a peculiarly American building, rooted to the land, a reflection of the pioneer spirit that still pervades the Midwest. It stands sturdily on a base of Kansas-quarried limestone and then rises skyward in a spectacular display of Montana-hewn fir.

Indeed, this little chapel in the college town of Lawrence expresses ambitions at once sublime and earthly. It was built, says its architect, Mike Shaughnessy of Kansas City, to allow worshippers "to learn of truth and beauty, knowledge and mystery." The chapel sits discreetly in a genteel residential area, almost as if it were a rambling, shingle-style house. "This is not a cathedral," says Shaughnessy. "You can't simply drive by and see the building. It has to unfold as you experience it."

Inside, there is overt yet subtle drama. The wooden roof, held up by concrete columns (twelve apostles, twelve columns), is simple yet complex, a pyramid crossed by beams and rafters and supported by struts that rise from the columns like tree branches. This is architecture with the surprising order found in nature, startling because it seems spontaneous but is, in fact, precise.

Though the chapel is bright and voluminous, there are dark corners that impart a sense that not all is known, or even knowable. The stations of the cross, tracing the story of the Crucifixion, are denoted by icons painted in traditional style by Brother William Woeger, a monk who lives in Omaha.

Sunlight filters through the wood-slatted glass gables. A single abstract stained-glass window, called *The Breath of God* (taken from Genesis 2:7), steeps an otherwise neutral environment in color. A copper and tin pipe organ gleams against one wall. Water flows continuously through a bronze baptismal font.

The priest who conceived this chapel is Father Vince Krische, the chaplain for the Catholic Center at the University of Kansas. He wanted a chapel that would be a place of meditation, worship, and joy. "We wanted it to express mystery," he says. "We wanted it to express peace and tranquillity. We wanted it to express tradition and timelessness."

The Catholic Center had long occupied a little house that has since been renovated as part of the new Saint Lawrence complex. The parish had grown, and by the middle 1980s, it was clear that the center needed its own place of worship. The local archbishop formed a committee—an architecture professor, a lawyer, a banker, an engineer, an artist, Father Krische, and himself—to lay

PREVIOUS PAGES: The interior of the wood and stone chapel is a tour de force of struts, beams, and rafters. Light pours in through slatted gables.
OPPOSITE PAGE: The brass baptismal font stands in front of *The Breath of God*, a colorful abstract stained-glass window by Kansas City artist Kathy Barnard.

out concepts for the building. To the forefront came the idea that this chapel could be, as Shaughnessy says, "the representation of the immeasurable in something that is measurable."

Saint Lawrence is spare, but its architecture derives from many sources, including Frank Lloyd Wright and the Prairie School, and the great master of the eclectic, Bernard Maybeck. Still, the regional craft tradition so important to the architecture of the turn of the last century is very much alive in this chapel. Alice Schwegler, and Alice Sabatini helped guide the building project and insisted on handcraft and originality. Thus, the stained-glass window came from Kansas City artist Kathy Barnard. The brass fittings were handwrought in Kansas City. The limestone was quarried in Cottonwood Falls, Kansas. The oak pews were made in Garnett, Kansas. Shaughnessy designed the oak lecterns, chairs, altar, and pedestals. For inspiration, he turned to yet another genius of the twentieth century, architect Louis Kahn, who in his work "tried so hard to find the source, or the beginning, the real essence," Shaughnessy says.

Father Krische himself asked the architects to go back to the foundation of it all, with the understanding, says architectural consultant Lou Michael, that "God was the first architect." For Shaughnessy, a devout Catholic, this meant a lot of prayer and a return to his roots. He grew up in small Kansas towns and spent summers pitching hay on his grandfather's farm. It was from his memory of those remarkable old Kansas barns, watching "shafts of light shoot through the space," he says, that the essential idea for Saint Lawrence, a lofty space stippled by sunlight, was born.

ABOVE: Brother William Woeger, a monk in Omaha, painted the Crucifixion scene that hangs above the altar. He made it specifically for the chapel.
OPPOSITE PAGE: The burnished pipes of the organ soar in the chapel interior.

MARJORIE POWELL ALLEN CHAPEL

At Powell Gardens, in the Missouri countryside, Fay Jones built a natural wonder, a beautiful chapel that invites contemplation.

Architect Fay Jones once commented that "you'd like to have it appear that man and nature planned and carefully arranged everything by mutual agreement, and then that each benefited immeasurably from the other." That is indeed the case in the chapel that he and his partner, Maurice Jennings, designed on a gently sloping lakeside site in Powell Gardens, in the Missouri countryside. The Marjorie Powell Allen Chapel seems both rooted in its place and somehow attached to the heavens.

It is a small but soaring space—like a Gothic cathedral in miniature, in wood instead of cut stone. A skylight runs along the roof ridge, and the effect from beneath is of a series of diamonds refracting sunshine—or, on bright nights, the moonlight. Though the structure is actually very straightforward, even elemental, it has an impossible feeling, as if it were an intricate puzzle put together by sleight of hand. "This is a simple building, but not a plain one," Jennings says. "There's a difference between simple and plain. This is also a complex building, but not a complicated one."

Though many chapels are for celebration and congregation, this one was intended primarily as a place of contemplation, of solitude. Powell Gardens is about thirty miles southeast of Kansas City, just past the little town of Lone Jack. And once you're in the gardens, you need some commitment to reach the chapel. You must walk through a sprawling visitors center out onto paths that meander around the lake and past the perennial garden filled with violets, honeysuckle, snowbank, phlox, mums, and 500 varieties of daylilies. The path crosses over streams and waterfalls to an open meadow alive with the sights and sounds of the prairie—the golds and rusts of wild grasses and the hum of crickets, locusts, and even frogs. A graceful wooden pavilion nestled into the hillside looks over the expanse of Powell Gardens' 915 acres. From there, the path heads downhill again into the shade of oak and hickory.

Quite suddenly, the vista opens up, and there is the chapel, tiny and transparent, seeming almost to grow out of the ground in a small clearing by the lake. It was here that Marjorie Powell Allen would sit and meditate, and it was here that she wished to build a chapel so that others could share in the serenity she found. She died in 1992, stipulating that the chapel must be nondenominational, open to all faiths at all times.

Jones and Jennings agreed to take it on. The modest Jones found sudden world renown in 1980 with his design for the extraordinary Thorncrown Chapel in Eureka Springs, Arkansas, one of the most admired small buildings in America.

The Powell Gardens chapel was one of the last buildings that Jones, who died in 2004, completed before he retired, leaving the firm in the hands of his

PREVIOUS PAGES:
Skylights that run along the edge of the chapel roof and walls of high windows let light fill the interior.
OPPOSITE PAGE: A model of complex simplicity, the chapel by architect Fay Jones seems to rise organically by a lake.
FOLLOWING PAGES:
The chapel, made of redwood, Minnesota limestone, and glass, is rooted in the natural world and sits amid prairie grasses and wildflowers.

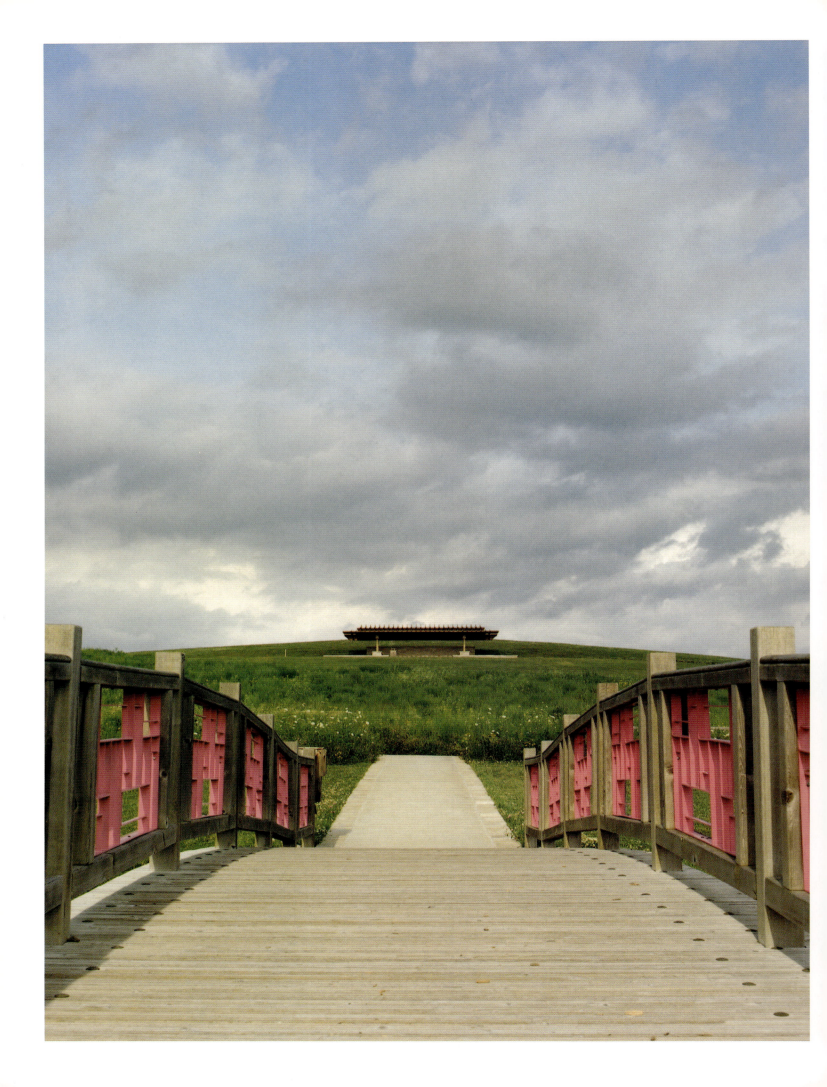

onetime student and first and only partner, Jennings. His work had become theirs, an architecture highly attuned to nature and proudly regional, most of it either in Arkansas or neighboring states. Jones has said that "any organic architecture is going to have this sense of belonging to the place where it is, seeming to grow out of the environmental context, responsive to particular places."

One can see any number of sources in Jones's work. The Powell Gardens chapel seems to draw from the Greek, the Gothic, the Japanese, from the work of the California craftsman architects Greene & Greene, from Oklahoma architect Bruce Goff, and from Frank Lloyd Wright, with whom Jones studied. Yet it is particularly and peculiarly original and rooted in its place.

"We had a very beautiful site to work with," Jennings says, "and we feel that there is no better manifestation of a superior power than nature itself. We felt it was important to open the chapel to nature." The chapel sits under a steep, sheltering roof that seems to hold it in an embrace, and its limestone base anchors it firmly to the ground. The structure is redwood, Minnesota limestone, and glass. Low-lying pews are of oak; the floor is flagstone. Jones and Jennings designed the handcrafted wall sconces, two candelabras, and a lectern.

From the inside looking out, there is a profound connection to nature, to the prairie grasses and wildflowers just outside. The view to the lake is shaped by a wall of glass crisscrossed in wood in a pattern that reiterates the geometries of the structure. The lake is the central organizing element of the garden, but it is the six-acre native prairie that compels. At one point the garden's caretakers tried to keep order amid the plants, but the prairie wouldn't be groomed. "The wild prairie is part of our heritage," says Eric Tschanz, Powell Gardens' director.

The gardens are not actually prairie but in the rolling hills between the Ozark Mountains and the flatlands that stretch through Missouri to Kansas and Nebraska. The late George E. Powell Sr., a farm boy who came to Kansas City in 1917 to work as a bank teller and who ended up owning the third-largest trucking company in America, bought the land in 1948 as a retreat from city life. It was then a working dairy farm. Powell died in 1981, and a few years later his three children, including daughter Marjorie, began laying plans to turn the land into a horticultural center.

Over the past decade, Tschanz has nurtured this transformation, planting thousands of different specimens as he worked toward the gardens' goal "to inspire people to appreciate beauty and conserve the natural environment." Initially, he thought visitors would use Powell Gardens to get ideas for their own yards or to identify new plants they wanted to buy; instead, overwhelmingly, he discovered that people came "seeking and finding tranquillity." It is not unusual, he says, to find a visitor lingering soundlessly in the Meadow Pavilion (also designed by Jones and Jennings, as were the Visitor Education Center, the origami-like light fixtures, and the outdoor furniture that tucks right into the landscape) or in the chapel. Not all is silent: though the chapel does not host regular church services, it is in demand for weddings, memorial services, and occasional concerts. And not all the visitors are silent meditators: former volunteer "chapel sitter" Lowell Whiteside witnessed two proposals "of the old-fashioned, down-on-one-knee sort."

OPPOSITE PAGE: A bridge leads to the open-air Meadow Pavilion, which was also designed by Fay Jones. From the pavilion, which is meant as a resting place on your journey, you can see gardens in all directions.

THE TOWN HALL

A small, modern chapel is both the sacred and the civic center of Windsor, Florida.

Leon Krier's new chapel in Windsor, Florida, is an ode to understatement. Yet for all its simplicity, it is also intricate and profound, a building intended to feed mind and spirit. "Objects on the landscape, by their sheer presence," Krier says, "can fill your heart with joy or rob it of all energy."

So it is with this one, a building both restrained and exuberant. By day, the sunshine offers a play of pattern as palms cast filigree shadows on the stucco. By night, the chapel glows, as luminous as a lantern. Officially called the Town Hall, it is a meeting hall like those in eighteenth-century New England, sacred and civic in its purpose, but its context is the carefully designed oceanfront polo-and-golf village. On Sundays and for weddings, sacred music spills out of the open doors; on other days, the hall might be used for lectures or a vote on greenkeeping.

Krier, who was born in Luxembourg and spent many years in London, lives in France. He is among the world's most eloquent—and influential—proponents of an architecture that is carefully detailed, well-proportioned, diligently crafted, and ultimately designed to be treasured.

As a theorist, he has swayed a generation of architects and thinkers who rally to his call for a return to the "beauty, efficiency, and practicality" of traditional architecture. Not the least of these is Prince Charles of England, for whom Krier created the plan for the new town of Poundbury. Krier has produced at least 10,000 drawings, yet he once wryly commented that the paper he has drawn on likely weighed more than the materials used to construct his first American building, a house in Seaside, Florida. The chapel at Windsor, done in conjunction with the American architects Scott Merrill and George Pastor, is his second.

Krier first visited Windsor in 1989, when only a few houses—the town's architectural style is derived from Anglo-Caribbean historic precedents—had been built. "These were a true revelation in quality and scale," he says, "and above all in the harmony and variety which I had believed quite impossible." The town—which was planned by the Miami firm of Duany Plater-Zyberk & Co.—now has 170 houses (ultimately there will be 350); the plan always called for a church, or "meeting hall."

"Initially, I imagined a building surrounded by deep arcades, with a relatively small cella in the middle," Krier says. "I personally wanted it to be of a civic, profane expression, monumental and republican, in the tradition of Washington and Jefferson." That idea soon gave way to a simpler one, that it be a nondenominational but sacred structure that could be used every day.

In a place where scale is carefully controlled, the chapel stands out. Its roof peaks at fifty feet, almost twice as tall as the rest of Windsor's buildings. Its comparative monumentality is purposeful, to let it be the visual focus of Windsor, to be its heart.

PREVIOUS PAGES: Medjool palms emphasize the narrowness and height of the chapel doors. The stucco facade has a plainness that is both modern and ancient—and ideal for a building that serves the spiritual and practical needs of a community.
OPPOSITE PAGE: Copper medallions that punctuate a frieze and a tall painted metal pylon are burnished details in the cool, pale interior.

Krier sought to make this a small building that would loom large in the landscape. Its roof seems almost etched against the sky; its honeycomb walls conjure images of other times, other places—the catacombs in Rome, the inner temple of Solomon in Jerusalem. There's a sense of enigma at work: are there references to the Swedish architect Erik Gunnar Asplund or the German Gothic in Poland, the British Arts and Crafts movement or the Hispano-Mooresque?

Others see all that. Krier, for his part, says that he sought "an aesthetic of simple and unpretentious elegance," in a sturdy structure with thirty solid pillars resting on a podium. The deep walls are punctured with half-circle windows. The rough stucco has, Krier says, "a freehand quality which softens the sheer repetitiveness and relentlessness of the architecture."

In silhouette, this is unmistakably a church, one that might have been around for a long time. The doors are imposing, and the walls have a heft that connotes consequence. "I love almost all architecture which survives from before 1945," Krier says, "and almost nothing from after that date. I don't think it is a matter of date, but of ideas and materials."

The palette is very plain—white walls and aqua doors, rafters, and ceiling. The soft blue-green paint seems to change from outside to in, from day to night. The oak pews and the altar are washed with a faint blue-green stain, a muted echo of the aqua paint, as if the ceiling had cast its glow downward. The sanctuary itself is virtually unornamented: a metallic painted pylon (actually a statue base) is set into a tall, narrow niche in the nave, and simple copper medallions run along the frieze.

Krier draws many of his ideas about architecture from what one might call life experience. He was born to a family of craftsmen, with a tailor father and a mother descended from a long line of carpenters. He was educated in part in the picturesque town of Echternach, Luxembourg. Much of its architecture dates from the eleventh to fifteenth centuries, and a part of town that was destroyed in World War II was rebuilt in an eighteenth-century style. It seems entirely in character that in Windsor the same sensibility could take hold, that the newest buildings could seem timeless. In this artful chapel—Krier calls it the "sacred heart" of the community—he has provided the town with both shelter and symbol.

**ABOVE:** Sunshine comes through the honeycomb walls and makes a wedding ceremony dazzle.
**OPPOSITE PAGE:** The chapel is small, but its steeply pitched roof soars over every other in town and helps give the building a towering presence.

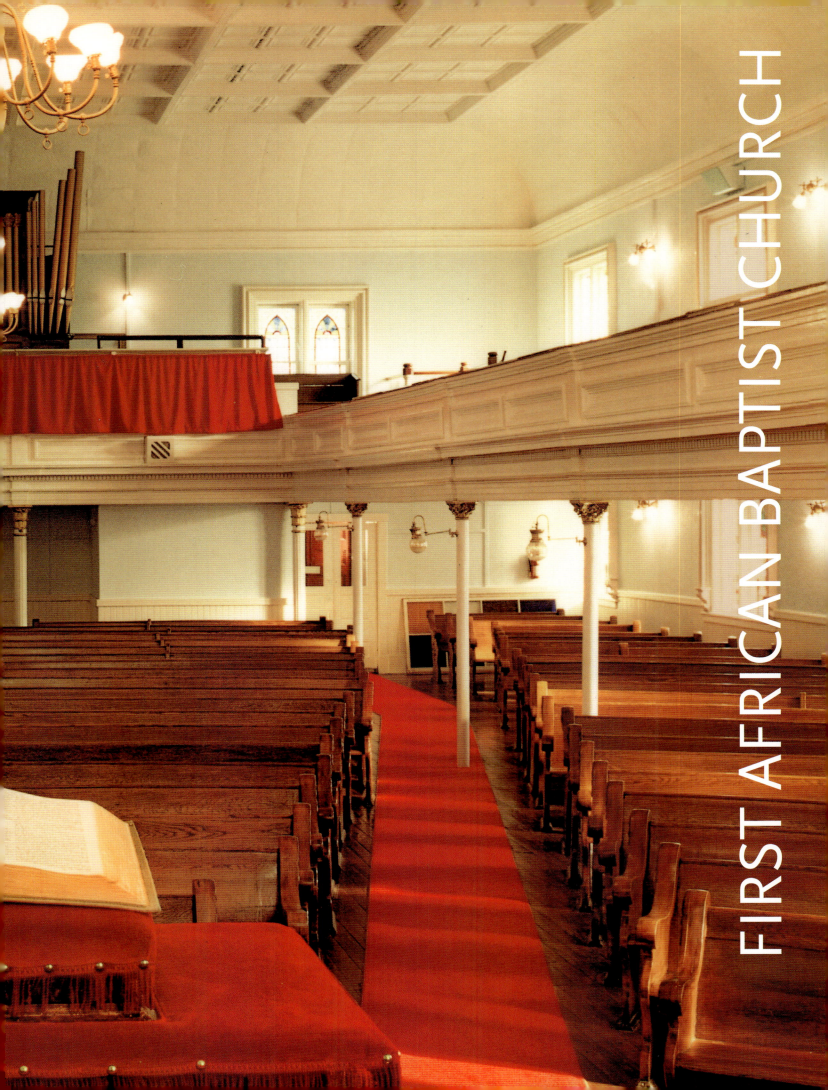

FIRST AFRICAN BAPTIST CHURCH

Slaves built a superb church in Savannah, Georgia, that became a stop on the Underground Railroad in the Civil War. Today's members retain the faith—and the activism—of the first congregation.

Its spire dates from before the Civil War, but its spirit dates from before the American Revolution. First African Baptist Church, on Franklin Square in Savannah, Georgia, was built by slaves and has played a key role in the community for more than two centuries. Recognized as what may be the oldest black church in North America, it traces its roots to George Leile, the first black Baptist missionary in Georgia.

In colonial days in the South, slaves, their white masters, and freedmen commonly worshipped together. Leile came to Savannah with his master, Henry Sharpe, a deacon in the Baptist church. When Sharpe recognized his slave's gift for preaching, he encouraged him to carry the gospel to others. Leile traveled the Savannah River, preaching to plantation dwellers and Yamacraw Indians.

In 1773, he founded the Ethiopian Church of Jesus Christ, and Sharpe's church licensed Leile to preach. Ordained in 1775 and freed to do the Lord's work, he was later imprisoned for sympathizing with the British during the Revolution, and he eventually emigrated to Jamaica.

Andrew Bryan, a slave and one of Leile's early converts, was ordained and served as pastor of Leile's Savannah church from 1788 to 1812. Twenty years after Bryan's death, the congregation—by then renamed First African Baptist—split over doctrinal differences, and more than 2,000 members followed Bryan's nephew, the Reverend Andrew Cox Marshall, to Franklin Square.

In 1857 the congregation began work on the current building. After laboring twelve-to-sixteen-hour days for their masters, they spent their free time on the construction; women carried bricks in their aprons. It took four years to complete the handsome church, whose walls are four bricks thick. In the archives, there is a brittle copy of the front page of a May 1861 edition of the *Daily News*. It notes the dedication of the church and the arrival in the city of the Seventh Regiment from New York, quietly heralding the upheaval to come.

During the Civil War, the church was a station on the Underground Railroad. Still visible are the airholes drilled into the heart pine floor of the lower level, in a diamond pattern representing the points of the compass. "That type of hole was also used for heating and some sort of air or ventilation," Rev. Thurmond Tillman, the current pastor, explains. So, arranged in a design, the holes could have passed for utilitarian decoration.

But James Oglethorpe's vision of the city may also have helped the church operate its stop on the Railroad successfully. In 1733, when Oglethorpe laid out Savannah in symmetrical blocks, he designated that two lots on each square

1857 REV. WM. J. CAMPBELL 1877

The handmade oak pews sit on a pine floor. Runaway slaves on the Underground Railroad hid in a four-foot space below. **OPPOSITE PAGE:** This window commemorates Rev. William J. Campbell, who was the pastor throughout the Civil War and into the Reconstruction era.

be reserved for public buildings that would be significant to community life—often a church. First African Baptist thus existed as a little black island in the heart of Savannah and attracted no particular attention to itself. Runaways hid below the floor, in a cramped four-foot space with access to a system of tunnels leading to the river two blocks away.

Today the church, with 1,200 members, is on the National Register of Historic Places. The oak pews in the sanctuary are arranged in a crescent to afford everyone a good view. In the balcony, African symbols, scratched into the end panels of the pews as the signatures of craftsmen, offer silent testimony to the workers' labor of love. In 1885, the church installed memorial stained-glass windows flanking the pulpit, featuring portraits of six pastors who succeeded George Leile. The downstairs auditorium retains its original gopher-wood pulpit.

First African organized the first black Sunday school, in 1826. The church also has a museum, where silver Communion sets that date to 1814 are displayed and where members maintain records from the 1800s and keep scrapbooks. But much of their history can't fit in glass cases: the long march of freedom, encompassing the flight from slavery, the civil rights struggle, and today's social activism. Andrew Cox Marshall, the third pastor, agitated for reform in the early nineteenth century when he approached white merchants, objecting to the long hours they made their white clerks work. The thirteenth pastor, Rev. Ralph Mark Gilbert, reorganized the Savannah chapter of the NAACP and worked to equalize pay for black and white teachers. Through his efforts, Georgia's first black police officers were hired.

Today, First African Baptist runs a free after-school homework tutorial program, a prison ministry, a homeless ministry, and a program to feed the hungry. The church has survived two centuries, Rev. Thurmond Tillman says, "by depending upon God's word and being a very resilient people who trusted in the Lord and allowed God to lead and direct us." The church's foundation of faith is as solid as its bricks.

ST. PATRICK'S CHURCH

In Oklahoma City, parishioners—including children, during recess—built an extraordinary mid-century modern church with their own hands.

This is a church based on improbabilities, a church that rose up against the odds. Built by its parishioners at night and on weekends, it is also high art, proof that modest means need not translate into modest achievements. Completed in 1962, St. Patrick's Catholic Church in Oklahoma City became one of the most admired—and award-winning—pieces of church architecture in its day.

The architect was Robert Lawton Jones, whose prestigious Tulsa firm, Murray Jones Murray, was known for modern, even avant-garde work. Jones had been a student of Mies van der Rohe in Chicago, where he gained "a special reverence for structures that used a new technology."

Jones had a soul mate in Monsignor Donald J. Kanaly, St. Patrick's forward-thinking priest. On a trip to Mexico, Monsignor Kanaly had been awed by the concrete structures of engineer Felix Candela. Jones and the monsignor went back there together. "I was not impressed with Candela's churches," Jones says, "but he had done wonderful spaces for warehouses and open-air markets."

For St. Patrick's, Jones followed that lead (and Candela became the engineer). He designed a roof that looks like a series of twelve freestanding umbrellas over tall concrete walls imprinted in reverse relief with fifty outsized concrete angels; inside the walls he inserted a sanctuary of clear glass.

Another participant was Frank Kacmarcik, a former Benedictine brother. An expert in liturgical art, he had become friends with many of the leading figures of the modernist movement and asked his friend Josef Albers, one of the country's foremost artists, to join the project. Albers, who had done stained glass for two churches but never anything sculptural, agreed—and for no fee.

To construct St. Patrick's, the entire parish, including young families of World War II veterans, gave up evenings and weekends for more than two years. Schoolchildren—at the time, there was a school but no church building, and Mass was said in the auditorium—spent their recesses working on it. Men and women labored to clear the land, build walls, install glass, wiring, and plumbing, and much more. "My mother was in charge of the women's work group," says Rita Haugen, who is still a staunch member of the church, "and she was also in charge of feeding the men on Saturdays. The theory was that if they went home to eat they wouldn't come back."

The volunteers traveled to the Oklahoma towns of Calumet, Ada, and Hydro to select stone for floors and walls. One parishioner, a trucker, drove with the associate pastor to Evansville, Indiana, to get the oak for the pews, all of which were then handcrafted by another member of the congregation. Others laid the floors in a Mondrian-like geometric pattern, made cabinets, and applied gold leaf to the altar screen that Albers had designed.

PREVIOUS PAGES: A series of fifty enormous angels seems to embrace the interior of the church. The angels were designed by Frank Kacmarcik, but members of the congregation made the oversized molds.
OPPOSITE PAGE: The bronze sculpture of St. Patrick outside the church is quite different from more familiar images. Here, shown in early Celtic clothes, he is rough and imposing.

The altar screen is simple and stunning, with marble-chip bricks set in an abstract rhythmic pattern. The hand-applied leaf is heavy and shimmery in some spots and barely visible in others. Albers created a wooden maquette for the screen and shipped it in pieces from New Haven, where he was teaching at Yale University. By telephone Albers described every inch to those who reassembled the model, which guided the screen's eventual fabrication. "It turned out exactly as he wanted it," Jones says.

The altar screen is a metaphor for the entire church, its artistry wrought from the most basic materials: concrete and glass, stone and wood. You arrive at the church after passing a statue of St. Patrick and a garden that was built in memory of Valerie Koelsch, a parishioner who was killed in the 1995 bombing of the Alfred P. Murrah Federal Building in downtown Oklahoma City.

The church itself, with its incised, windowless concrete walls and austere abstract bell tower, should be forbidding, but it is not. You walk through the comparatively dark space of the baptistery into the glass-walled sanctuary that is cocooned within the space, a church within the church, with gathering space on the sides. Light enters only through skylights tucked between the roof and the outer walls, but there is plenty of it.

The experience of the space is a profound one, but it is the rows of angels—in their iteration they are almost cubist, with their heads turned sideways, their wings uplifted— that dominate the space. Kacmarcik designed those angels, but the parishioners created the oversized plaster of paris molds. Once these were in place on boards, concrete was poured over them to create the wall panels, which when dry bore the imprint of the angels. A crane lifted them into place.

If you stand in certain spots in the church, the angels are reflected in the sanctuary's glass walls but are also visible through them, so that it truly seems that a heavenly host has descended on St. Patrick's. They are great fodder for the spirit, and for the imagination. "The angel wings shook holy dust down on the ground where the church was going to be," Dung Le wrote as part of the celebration of the building's fortieth anniversary, when he was in sixth grade. "Then the dust blew hard onto the slabs of concrete in the shape of angels."

The parish is much changed these days, an assemblage of longtime members and newer worshippers from far-flung places—Vietnam and elsewhere in Asia, as well as Mexico, Guatemala, and Honduras. A recent priest, Father Stephen Bird, commissioned the striking bronze sculpture of St. Patrick—one that shows him in early Celtic garb, a hirsute, rougher, far more compelling depiction than is often seen. The current priest, Father Thomas McSherry, served in Guatemala for 17 years; coincidentally, he grew up attending a Tulsa church also designed by Jones. St. Patrick's School—which was what brought people to the parish in the first place—closed its doors in 1989, but the church still fills with parishioners who went to school there, or sent their children there, and who remember the momentous years of church building.

Rita Haugen is the unofficial archivist, the keeper of memories. St. Patrick's is inextricably tied up with the triumphs and tragedies of her life. As a teenager, she was in charge of the babysitting that allowed parents to work on the construction. Her mother died on July 6, 1961, and the first Mass inside the then rough structure was her funeral Mass. Last year, Haugen's son died, and there was another funeral Mass at St. Patrick's. For her, it is not just the concrete angels that are keeping watch.

TOURO SYNAGOGUE

America's oldest synagogue, built in Newport, Rhode Island, and facing Jerusalem, is a perfect work of Colonial architecture.

On a Saturday morning late in autumn in Newport, Rhode Island, when the frost is on the tourists, a group of men, most of them in their sixties and seventies, gather in a small, spare building on a quiet street and make history. The Touro Synagogue is beautiful, and filled with ironies.

The building belongs to the history of America; the sound of the men belongs to an older history. They sing a Psalm of David in the language of David. Men have been singing so in this building since 1763. It is a house of toleration, a National Historic Site, and when it is empty it is very handsome, but when the men gather on the Sabbath and sing, it becomes a work of art.

At this late date in the life of the painted brick and the pillars of the synagogue, no one fears that it will crumble, but there could be an end to history. Newport's Orthodox Jewish community is small: the young leave to find work, and marry out of the faith, and the old engage in their dance with forever. In summer, Jewish tourists fill Touro, and prayer is a mighty sound, but when the seasons change, the chant grows softer. The fear is that the synagogue will become a museum. No one thinks this crisis has come, but when it does, it will be in winter.

To sort the art from the history and to grasp the ironies requires some sense of Newport in its several incarnations. The town has had three lives, and this may be the last of them, when what was once a town becomes archaeology. But it was not that way when the Sephardim, the Jews of Spain and Portugal, came to Newport in 1658, at the beginning of the town. They had been wandering across Europe and into the New World since 1492, when they were expelled by the Spanish Inquisition. Finally to find the colony founded by Roger Williams on the principle of religious toleration must have seemed very like a miracle.

By 1677, they felt secure enough to establish the wanderer's first sign of permanence: they bought a piece of land, blessed it, and made it their burial ground. In the blunt fashion of the time, the new street in front of the cemetery was named Jew's Street (it was eventually changed to Touro Street).

Early in the eighteenth century, Newport was one of the busiest ports in the colonies. The commercial and cultural life of the town blossomed, and the Sephardim lived as freely and successfully as they had in Spain before the Inquisition. Aaron Lopez was known as the Merchant Prince of New England. Ezra Stiles, the Congregational minister and eventual president of Yale College, studied Hebrew with Isaac Touro, the religious leader of the Sephardic community.

It was time to build a synagogue. The task of designing it went to Peter Harrison, the architect of Christ Church in Cambridge, Massachusetts, and of King's Chapel in Boston, and he produced his masterpiece, perhaps the perfect work of American Colonial architecture. It was dedicated on December 2, 1763.

PREVIOUS PAGES: Built in 1763, when Newport was a busy port, this temple has the simple beauty of a New England church.
OPPOSITE PAGE: The bimah, with an extended reading desk, is at the center of the "splendidly illuminated" synagogue, which was designed by the architect Peter Harrison.

How the men must have sung that day! The *Newport Mercury* of that week gave some sense of the beauty of the living building when it reported that "the most perfect of the Temple kind perhaps in America, and splendidly illuminated, could not but raise in the Mind a faint Idea of the Majesty and Grandeur of the Ancient Jewish Worship mentioned in Scripture."

In his journal, Stiles described the building "of Brick on a Foundation of free Stone. A gallery for the Women runs round the whole Inside, except the east end, supported by Columns of Ionic order, over which are placed correspondent Columns of the Corinthian order supporting the Ceiling.

"The Pulpit for Reading the Law, is a raised Pew with an extended front table; this placed about the center of the Synagogue ... being a Square embalustraded Comporting with the Length of the intented Chancel before & at the Foot of the Ark.

"There may be Eighty Souls of Jews or 15 families now in Town." When the British occupied Newport, at the beginning of the Revolutionary War, half the population deserted the town. After the war, only a few people returned. In 1790, with the fate of the synagogue no longer certain, the president of the United States visited and received these words from its warden, Moses Seixas: "Deprived as we heretofore have been of the invaluable rights of free Citizens, we now ... behold a Government erected by the Majesty of the People—Government, which to bigotry gives no sanction, persecution no assistance—but generously affordens to All liberty of conscience, and immunities of Citizenship." In his reply, penned a few days later, George Washington cribbed the key phrases about bigotry and persecution from Seixas's letter.

But not even Washington's good wishes could help. When the community dissolved a few years later, the building lost its life. It became a meetinghouse, the state legislature convened there briefly, and then it fell into silence and decay.

Restoration began in the mid-1800s, paid for largely by the Touro family, but it was not until 1883 that the building lived again. When the robber barons came to Newport and began to compete with one another to see who could build the most ostentatious display of raw wealth, there were only crypto-Jews among them.

A Conservative synagogue was built nearby in 1977. The small modern structure belies the notion that God is the favorite patron of architects because He forbids imitation and worship of the lowest cost per square foot. The Touro Synagogue may yet fall into archaeology over the issue of freedom, for in its orthodoxy it requires that women sit in the gallery, and it does not count their presence in the minyan of ten required to chant certain prayers. The conflict between ritual and liberty excludes many, among them the late Ruth Whitman, who was the foremost American translator of Yiddish poetry. She would not attend the synagogue, for she considered the ancient rules regarding women an affront to equity.

Of the more than 700 Jews on the island, about a third belong to this famous Sephardic synagogue, which sits at an angle facing east toward Jerusalem. Only one family in the congregation is Sephardic; the rest are of Ashkenazi origin. Unlike the Hebrew and Moorish character of the great synagogues of Spain before the Inquisition, Touro has the austere beauty of a New England church. There is, in the very walls of the synagogue, a sense of tolerance, of accommodation, of survival.

A church in Pocantico Hills, New York, is home to windows of the soul—stained-glass works by Marc Chagall and Henri Matisse.

You could easily pass by the Union Church of Pocantico Hills, New York, and never know of the extraordinary visual and spiritual experience within. This simple stone building has ten stained-glass windows by Marc Chagall and Henri Matisse, offering a profound celebration of the relationship between art and religion.

Inside, luminous blues, purples, yellows, and greens envelop you. "The first thing that hits you is the color, and initially that's all you can see—your eyes need time to adjust," says Susan Cavanaugh, the art historian and site manager who oversees the church for the Historic Hudson Valley, a preservation organization.

As the sun shifts, the light and colors change dramatically. "It is really moving," says the church's minister, Paul DeHoff. "Sometimes it gives me chills."

Matisse did the Rose Window. It was his last work, which he designed in 1954, literally on his deathbed. It is subtle and abstract, a study in color and form that manifests itself as a flower, each shape differing slightly from the rest. The effect is at once calming and compelling.

The Chagall windows—which he began in 1963, when he was 76—are kinetic by contrast. Chagall did not view himself as a religious man, but often invoked the Scriptures in his work.

The story of these windows is intertwined with patronage and philanthropy. Union Church dates from 1922 and was endowed, in part, by John D. Rockefeller Jr., who—like his parents, children, and grandchildren—worshipped there when he spent weekends at the family's Pocantico Hills house, Kykuit. Later, some of the third generation—Nelson, David, Laurance, Winthrop, John D. III, and Abby—donated the windows.

Even today, the Rockefellers keep close watch. In the early 1980s, when the congregation dwindled, the family helped work out an agreement to transfer the building to the care of the Historic Hudson Valley. It is still a working, nondenominational Protestant church with Sunday services, and open to the public.

"I love seeing the expressions of people who come to the Union Church by chance," says Mark F. Rockefeller, part of the family's fourth generation. "Even for those who come specifically for the aesthetic experience, I think that their spiritual and emotional batteries are in some way recharged."

The church, designed by Viennese-born architect Ludwig W. Eisinger, is austere, with white walls and wooden pews. Originally, it had semiopaque and amber leaded-glass windows with wooden tracery. The church was unchanged until several years after Abby Aldrich Rockefeller died in 1948. Her six children decided that a window by Matisse would be a fitting tribute to their mother,

PREVIOUS PAGES:
The church, designed by Viennese native Ludwig W. Eisinger, has a simple stone exterior, but it houses stained-glass windows by two of the twentieth century's greatest artists.
OPPOSITE PAGE: Matisse made his abstract Rose Window for the chancel, mindful of "the atmosphere which is to be created with this chapel."

one of the founders of the Museum of Modern Art and a friend of the artist. Matisse eventually agreed. "The absorbing aspect of this work for me was to express myself in a well-defined space," he wrote.

The Rockefellers then turned to Chagall. His Good Samaritan window is a tribute to John D. Rockefeller Jr.'s humanitarian efforts. Chagall himself had been saved from the Nazis by the American journalist Varian Fry, whose work to smuggle antifascist refugees out of France was funded in part by the Rockefeller family. The window is inspirational, a kaleidoscope of figure and form so complex that the church's pastor asked for an interpretation. Chagall replied: "I have not put in this work any detail that is not in accord, inwardly and mystically, with the essence of this parable. I believe that any special and detailed explanation of the content of a work of art by the artist himself takes away some of its value. Each must, and can, understand what he experiences within himself."

A window of the Crucifixion is based on the biblical verse "Ask, and it shall be given to you; seek, and you shall find; knock, and it shall be opened unto you." It is a memorial for Michael Clark Rockefeller, who at age twenty-three was lost at sea during a 1961 anthropological expedition to New Guinea. The other windows depict six prophets—Elijah, Jeremiah, Isaiah, Ezekiel, Daniel, and Joel—and the angel guarding the Garden of Eden after Adam and Eve's expulsion. Each window is distinctive, with its own colors and character.

Joyous and solemn, the windows have such depth that Cavanaugh still discovers nuances in them. "I like to think," she says, "that this church was destined for these windows."

ABOVE: Though Matisse was not in good health, he agreed to make the Rose Window—which was his final work—in honor of the late Abby Aldrich Rockefeller, who had been a friend of his.
OPPOSITE PAGE: The Crucifixion, one of nine windows by Marc Chagall, is in memory of Michael Clark Rockefeller, who was lost at sea in 1961, when he was only twenty-three.

227

The iconic white steepled church—the kind seen on Christmas cards and calendars for generations—survives as more than just a New England emblem in Grafton, Vermont.

Only back roads lead to the picturesque Vermont village of Grafton. It's a town that, like so many others, has seen its share of prosperity and suffering, stories of early American life writ both large and small. The building that more than all others embodies this is the white clapboard church where townspeople have worshipped for almost a century and a half.

The church is a study in simplicity and symmetry, a quiet but powerful presence. Inside, it is warm rather than austere, with gray wooden walls stenciled in pale green. The organ is original, a Nutting made in nearby Bellows Falls. A parishioner winds the Regulator clock that has kept time over the decades. The lecterns and pews, made of oak and walnut and maple and pine, bear witness to the array of wood in the surrounding forests.

The church, built in 1858, sits in a position of some prominence on Main Street, memorable, in part, because it presides so serenely over the landscape. In Grafton, it is known quite simply as "the White Church."

No architecture is more American, more closely tied to our New England roots, than the white clapboard church. It signifies the historic fight for freedom of worship, speech, governance, and more. "A lot of democracy is idealized in this form," says John W. Cook, an emeritus professor at Yale Divinity School, a former president of the Henry Luce Foundation, and a scholar of American church architecture.

The first settlers of America came here to be free to worship as they chose; their church was not to be one set apart from, or above, the people. It was not to represent the aspirations of the afterlife as much as the daily travails of the here and now. Thus, says Cook, people drew their church architecture from the local vernacular of post-and-beam construction clad in clapboard to invent a new form of architectural expression. "It was a big house for worship and community," Cook says. Ultimately, bell towers were added ("a borrowing from the Church of England," he says), and classical details, to achieve the wooden church as we think of it today—an ageless emblem of American credos.

On a snowy winter Sunday, when traffic is sparse and parked cars sit obscured under billowy white drifts, time vanishes entirely. "It could be thirty years ago, or fifty years ago," says the Reverend Roger L. Brown, who served as interim pastor of what is officially the Grafton Church. There are residents who trace their ancestry to the town's founding and discuss local political issues with fervor. Grafton is still, as it has been for almost 225 years, run by town meeting, and on Sundays worshippers still open the old Pilgrim Hymnal to sing the words their forebears did.

Yet change is the constant for all of America, and Grafton is no exception. "You can count on your hands the number of people who have lived here for

ABOVE: The sanctuary has remained unchanged over the years, even as the town of Grafton has endured shifting fortunes.
OPPOSITE PAGE: The unadorned cross on the altar, flanked by flowers, provides a perfect metaphor for the early New England church and what it meant to history and culture. The first settlers came to America to find freedom of worship, and thus stripped both the church and the service of embellishments.

more than forty years," says Bea Fisher, who is one of the people to be counted. She joined the church in 1944 as a young bride, married to a descendant of one of Grafton's first families, and has worshipped there ever since. In the 1930s, her brother, Leighton Barnes, restored some of the lighting, including the original chandelier, which he found in the attic of the parsonage. Fisher is the church's unofficial historian and, more, the memory of both the building and the congregation.

She is also one of those who have witnessed Grafton's fortunes rise and fall. The town was founded in 1754 under a British land grant charter; abundant trees provided the settlers with logs and lumber for the construction of houses and the crafting of furniture. By 1780 there was a permanent small settlement, and the first town meeting was held in 1783.

Grafton's varied sources of income have included, over the years, wood, wool, soapstone, cheese, and farming. By the middle of the nineteenth century, farming had moved west, the woolen industry was in decline, and Grafton began to be passed by. In 1963 the Windham Foundation—founded by Dean Mathey, a Princeton, New Jersey, banker—bought and restored the Old Tavern, which like the church was a centerpiece of town life. It was the first of numerous such architectural and economic development projects, which have saved and restored Grafton's cheese factory, nursery, and garage, as well as smaller businesses and a farm. The foundation has also bought and restored a number of Grafton's houses. The population today is about 649, half of what it was at the town's peak.

Grafton actually has two churches. The first, built in 1833, is brick, and began as the Congregational Church, while the white one was built by Baptists, which is unusual. "In

ABOVE: The altar table, a gift to the church, is more ornate than you might expect in a country church, where, typically, simplicity rules.
OPPOSITE PAGE: The pews are made of local hardwoods and kept well-polished so that they shimmer as the crisp Vermont sunlight cascades through clear glass windows.

my experience," says Eli Prouty, the curator of the town's historical museum, "in New England, Baptist churches were always brick and Congregational churches were always white." The two congregations merged in the 1920s when they could not support two churches and two ministers; worship services are held half the year in one church and half in the other.

Over the decades, the White Church lost its steeple and acquired another. The horse stalls out back are long gone. The organ, which dates from 1868, has been electrified. A small addition came in 1969, and recently the basement was renovated and a hydraulic lift was added—a new expression of democratic ideals, access. But the church is much as it has been and will be, a place of worship and a symbol of so much history. Here in Grafton, where the past is the future, it all seems abundantly clear.

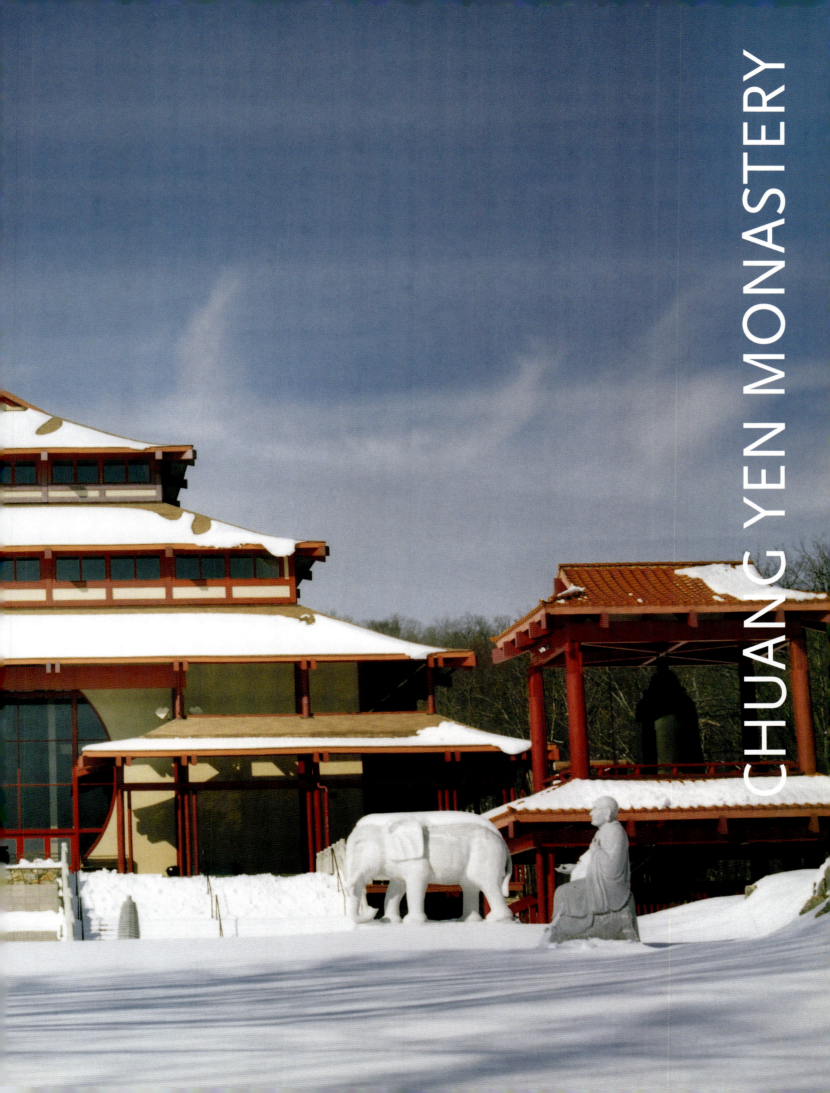

CHUANG YEN MONASTERY

Conceived by I. M. Pei, an enormous Tang dynasty temple dominated by a 37-foot-high Buddha rises in the woods of Putnam County, New York.

The gravel road was narrow, winding, and unfamiliar. Suddenly, there was something looming ahead through the treetops—something large, white, and unearthly. No, not a UFO, which is just what you might expect to encounter amid the steep hills and thick woods of Putnam County, New York—the kind of terrain space aliens seem to favor when they're in the market for an abductee or two. This was something more surprising: a Buddha—snow-white, 37 feet high, sitting in solitary, radiant, pensive splendor. Had it been merely a UFO, I might have shrugged and kept driving, but this stopped me in my tracks.

It was sometime in 1994, and, exploring the back roads near the cottage where I was staying, I had turned onto a road marked with a sign bearing Chinese characters and the words "Chuang Yen Monastery." Over the course of the next two years, the Buddha gradually disappeared from view as an eighty-five-foot-high temple, in the classical Chinese style of the Tang dynasty, rose around it. The statue was to be an enormous indoor Buddha and had been put in place first. By May 24, 1997, when the Dalai Lama dedicated it before a crowd of some 4,000, the Great Buddha Hall, as the temple is known, was complete, minus a few finishing touches. Today it's the overhanging orange-tiled roofs, the red pillars and beams, and the yellow-beige walls of the new temple that you see as you drive through the wooded, half-wild monastery grounds. Inside, in the soaring, simple, almost unadorned interior space dominated by formidable wooden beams, the vast Buddha, made of cold-cast marble and fiberglass, rests serenely.

So what's a nice Tang dynasty temple doing in a place like this, in the early twentieth century? The place, the rural township of Kent, New York, is a rugged, rocky landscape, punctuated by iron mines in colonial times, now given way to exurban houses and Range Rovers. Much of the credit for bringing the Tang dynasty and Buddhism here belongs to C. T. Shen, a good-humored, unassuming man who was born in China in 1913. After coming to the United States in 1952, he founded a shipping company and deepened his interest in Buddhism, studying and eventually lecturing. In 1980 he donated the 125-acre property for the Chuang Yen Monastery, which he and the late Reverend Ming Chi helped shepherd into existence.

A small group of monks and nuns lives in the dormitories at the monastery, which also has a library, dining halls, and a smaller, older temple. On weekends, Chuang Yen draws hundreds of visitors and worshippers, many of whom attend classes in Buddhist meditation and doctrine or eat the vegetarian lunch offered on Saturdays and Sundays.

Shen consulted a friend, architect I. M. Pei, while making plans for the Great Buddha Hall, which would be designed in detail by Edward A. Valeri, a

PREVIOUS PAGES:
The monastery's Great Buddha Hall is in the classical style of the Tang dynasty, 618–907 A.D. The door set within the circular window symbolizes the everyday world surrounded by the eternal one.
OPPOSITE PAGE: A striking, large colored statue of the compassionate Kuan-Yin Bodhisattva is more than 1,000 years old and was recently restored. It stands in the monastery's Kuan-Yin Hall, which is used for retreats and other events.

ABOVE: One of the world's largest indoor Buddhas, made of cold-cast marble and fiberglass, presides over the monastery. Twelve bodhisattvas, who grant prayer requests, circle the base of the statue.
OPPOSITE PAGE: Ten thousand "Little Buddhas," each a foot tall, stand for the infinite aspects of the world and form a semicircle around the great Buddha.

Long Island architect who had already designed the other buildings on the grounds. Pei conceived the austere, lofty interior, which is not elaborately ornamental in the manner of a traditional Chinese temple, in order to focus attention on the Buddha statue (something also accomplished by the converging interior light).

The Buddha weighs about twenty-two tons. Chinese sculptor Chang-Geng Chen made a full-scale model, which was coated with a plaster that hardened to form a mold. The mold was laminated with a mixture of cold-cast marble and fiberglass, then reinforced with steel by Colbar Art of Long Island City, New York. The statue, built in three sections, was pieced together on the site by a large crane in September 1993. For a year, the Buddha was on his own. Work on the 24,000-square-foot, $6-million-plus temple began the following fall.

But long before the Buddha appeared, there was the matter of feng shui, the ancient Chinese art of building design and alignment. A Taiwanese expert was brought in to roam the property and to choose the most auspicious site. That's why the temple faces south—toward the sun—with water (a nearby small lake overlooked by a statue of Kuan-Yin, a female deity) in front of it, and a ridge, like a protective mountain, in back, to the north.

ABOVE: On rows of small figurines of Buddha, visitors leave the names of someone —an ailing grandfather, for instance—for whom they are offering prayer.

OPPOSITE PAGE: Chang-Geng Chen's 104-foot-long mural, which curves around the three-foot-high Buddha, depicts the Pure Land, or Western Paradise revered by many Chinese Buddhists.

Valeri then set to work, immersing himself in the study of Tang dynasty temples and figuring out how the traditional style could be translated into modern materials. Traditional materials would require traditional maintenance, meaning a very large, very unaffordable workforce. So beneath the tiled roofs is asphalt, to prevent leaks, and beneath the wood floor is concrete. The wooden arches and support beams are laminated Douglas fir.

Unlike Western religious architecture, such as Gothic cathedrals, the classical style of East Asian Buddhist temples isn't specifically religious. By the time of the Tang dynasty, the Indian-inspired Buddhist pagoda had given way to the image hall. It adopted the conventional style of other important Chinese public buildings, with their curved, graceful overhanging eaves which were originally purely functional, meant to ward off the hot sun and torrential rains. What made a temple religious was what was in it. Inside the Great Buddha Hall, aside from the statue, are cushions on which worshippers may kneel or prostrate themselves before the Buddha, along with a pot in which sticks of incense are placed.

Nevertheless, certain features of the Great Buddha Hall itself can be seen as reflecting or symbolizing Buddhist teachings. Richard Baksa, a teacher of

courses in Buddhist doctrine at Chuang Yen, told me that the large circular window at the entrance to the temple symbolizes spiritual perfection and eternity, while the oblong door within the circle represents the everyday world enclosed by the eternal world. Seen from the outside, three rows of windows suggest multiplicity and separation, but inside there is only the unified space, the one inner truth of the Buddha. The rock walls that form part of the foundation are made of large boulders and small stones, symbolizing the contribution that everyone, regardless of social stature, makes to the faith. A large iron bowl inside the temple is derived from the begging bowl that was chimed when the Buddha was about to begin his teachings. A large wooden fish is a Chinese symbol of spiritual awareness (fish are believed never to close their eyes).

The Buddha, with eyes open, sits in the lotus position on a lotus flower, his right hand holding the index finger of his left hand. This is the hand sign (mudra) of universal enlightenment, and the Buddha is called the Buddha Vairocana, also known as the Universal Buddha. Shen chose this representation of the Buddha because it is venerated by many Buddhist sects. Many of the visitors to Chuang Yen are Chinese immigrants and Chinese Americans who are practitioners of Pure Land Buddhism, but the monastery accommodates Zen, Ch'an, Tibetan, and other Buddhists.

The lotus flower symbolizes the spiritual path a Buddhist must take, sprouting in underwater mud (ignorance) and blossoming in air and light (enlightenment). Around the base of the stylized flower, Chen laced a painted bas-relief portraying twelve bodhisattvas, who Pure Land Buddhists believe function much as Catholic saints do, granting prayer requests according to their specialty. On a semicircular tiered platform surrounding the Buddha are, in orderly ranks, the traditional 10,000 "Little Buddhas," foot-high statues representing the infinite aspects of the world. (To many Americans, they may look a bit like the crowd in the bleachers of a baseball stadium.) Along the curved base of the platform, Chen has painted a mural depicting the Pure Land, the Western paradise in which many Chinese Buddhists believe. It doesn't look very different from Christian Sunday-school representations of heaven, featuring fluffy pink and purple clouds against a sky-blue background and androgynous angelic figures playing stringed instruments, except that some of these angels are bare-chested.

A few decades ago, Buddhism in the United States was confined to relatively small Asian-American communities and was otherwise the esoteric pursuit of a handful of scholars, intellectuals, and Beat poets. Zen, one of the best-known forms of Buddhism, was turned by a powerful American cultural imperative into a kind of easy, instant enlightenment, which in its austere Japanese and Chinese (Ch'an) versions it definitely is not. Today, Buddhism is better understood and is flourishing in the United States. Thousands of Americans—including movie stars, musicians, artists, and writers—visit Buddhist monasteries and temples established during the past thirty-five years, and many spend weeks there, learning meditation. The Great Buddha Hall at Chuang Yen is an imposing symbol of these developments, and perhaps the stunning solitary apparition of the Buddha that preceded it was a bellwether.

OPPOSITE PAGE: In Kuan-Yin Hall, a Ming dynasty statue of the Buddha Sakyamuni wears a scarf someone left as an offering.

The following photographers worked on this book.

Erica Ackerberg was the tireless coordinator and researcher for most of the projects.

Richard Barnes: First Church of Christ, Scientist

Randi Berez: Chapel of Saint Ignatius

Diane Cook and Len Jenshel: Touro Synagogue

Reuben Cox: All Saints Chapel (North Carolina)

François Dischinger: The Diamond A Ranch personal chapel

Amy Eckert: Grafton Church; Chuang Yen Monastery

Doug Hall: Crystal Cathedral

Todd Hido: Enmanji Buddhist Temple

Russell Kaye: Gethsemane Episcopal Cathedral

Raimund Koch: St. Patrick's Church; Brigham City and Provo Tabernacles

Nikolas Koenig: Congregation B'nai Yisrael; Civic Center Synagogue

Laurie Lambrecht: Marjorie Powell Allen Chapel

Rick Lew: All Saints', St. James's, St. Peter's-by-the-Sea, and Trinity (Maine)

Thomas Loof: First Presbyterian Church

Joshua Lutz: Islamic Cultural Center

Alen MacWeeney: Memorial Church; Trinity Church (Boston); Union Church

Emily Minton Redfield: First African Baptist Church

Jason Schmidt: Central Synagogue; Gumenick Chapel

Noah Sheldon: Saint Andrew's Dune Church

Juliana Sohn: Memorial Church; the Reverend Peter J. Gomes

Ben Stechschulte: Christ Church Cranbrook

Burk Uzzle: San Juan Bautista Mission; The Town Hall

Roy Zipstein: Saint Paul's Episcopal Church; Saint Lawrence; Flushing Quaker Meeting House; Hyde Hall, Whitney, and Belcourt Castle personal chapels

# HOUSE OF WORSHIP LOCATOR

All Saints' Chapel
9 Cooper Ln.
Orr's Island, ME 04066

All Saints Chapel
236 Carolina Ave.
Linville, NC 28646
828-733-2978

Brigham City Tabernacle
251 South Main St.
Brigham City, UT 84302
435-723-5376

Central Synagogue
123 East 55th St.
New York, NY 10022
212-838-5122
centralsynagogue.org

Chapel of Saint Ignatius
Seattle University
901 12th Ave.
Seattle, WA 98122
206-296-5587
seattleu.edu/chapel

Christ Church Cranbrook
470 Church Rd.
Bloomfield Hills, MI 48304
248-644-5210
christchurchcranbrook.org

Chuang Yen Monastery
2020 Route 301
Carmel, NY 10512
845-225-1819

Civic Center Synagogue
49 White St.
New York, NY 10013
212-966-7141

Congregation B'nai Yisrael
2 Banksville Rd. (at Route 22)
Armonk, NY 10504
914-273-2220
cbyarmonk.org

Crystal Cathedral
12141 Lewis St.
Garden Grove, CA 92840
714-971-4000
crystalcathedral.org

Enmanji Buddhist Temple
1200 Gravenstein Highway South
Sebastopol, CA 95472
707-823-2252
sonic.net/-enmanji/

First African Baptist Church
23 Montgomery St.
Savannah, GA 31401
912-233-2244
oldestblackchurch.org

First Church of Christ, Scientist
2619 Dwight Way
Berkeley, CA 94704
510-845-7199
1stchurchberkeley.org

First Presbyterian Church
1101 Bedford St.
Stamford, CT 06905
203-324-9522
fishchurch.org

Flushing Quaker Meeting House
137-16 Northern Blvd.
Flushing, NY 11354
718-358-9636

Gethsemane Episcopal Cathedral
3600 25th Street South
Fargo, ND 58104
701-232-3394
gethsemanecathedral.org

Grafton Church
55 Main St.
Grafton, VT 05146
802-843-2346

Gumenick Chapel at Temple Israel of
Greater Miami
137 Northeast 19th St.
Miami, FL 33132
305-573-5900
templeisrael.net

Islamic Cultural Center of New York
1711 3rd Ave.
New York, NY 10029
212-722-5234

Marjorie Powell Allen Chapel
Powell Gardens
1609 N.W. U.S. Highway 50
Kingsville, MO 64061
816-697-2600
powellgardens.org

Provo Tabernacle
100 South University Ave.
Provo, UT 84601
801-370-6655

Saint Andrew's Dune Church
12 Gin Ln.
Southampton, NY 11968
631-283-0549

Saint James's Chapel
Winslow Homer Rd.
Prouts Neck, ME 04074

Saint Lawrence Catholic Campus Center
1631 Crescent Rd.
Lawrence, KS 66044
785-843-0357
st-lawrence.org

St. Patrick's Church
2121 North Portland Ave.
Oklahoma City, OK 73107
405-946-4441
stpatrickokc.org

Saint Paul's Episcopal Church
Fredericksted
St. Croix, VI
340-772-0818

St. Peter's-by-the-Sea
Shore Road
Cape Neddick, ME 03902
207-361-2030
st-peters-by-the-sea.org

San Juan Bautista Mission of Corpus
Christi Catholic Church
3116 NW 2nd Ave.
Miami, FL 33127
305-635-1331

The Town Hall
c/o Windsor Sales Office
10680 Belvedere Sq.
Vero Beach, FL 32963
772-388-8400

Touro Synagogue
85 Touro St.
Newport, RI 02840
401-847-4794
tourosynagogue.org

Trinity Church
206 Clarendon St.
Boston, MA 02116
617-536-0944
trinitychurchboston.org

Trinity Church
914 York St.
York Harbor, ME 03911

Union Church
555 Bedford Rd.
Pocantico Hills, NY 10591
914-332-6659
hudsonvalley.org/unionchurch

# Acknowledgments

Our thanks to S. I. Newhouse, Jr., Charles H. Townsend, John W. Bellando, and Thomas J. Wallace for their support.

For their unwavering dedication and keen eye, we thank Katrine Ames, Anthony Jazzar, Lucy Gilmour, Trent Farmer, Greg Wustefeld, James Cholakis, and the House & Garden research staff.